EXPERIMENTAL WATERCOLOR TECHNIQUES

EXPERIMENTAL WATERCOLOR TECHNIQUES

BY BUD SHACKELFORD A.W.S.

Watson-Guptill Publications/New York
Pitman House/London

My thanks to my students all over the country who inspired me to put my teachings into print. At Watson-Guptill, my thanks to Don Holden, Dorothy Spencer, and Bonnie Silverstein, for their assistance and enthusiasm, and to Jay Anning for the design of this book. I especially want to thank my wife Dot for her hours of editing and typing the manuscript. Finally, to my painting friends who contributed some excellent examples of watercolor technique, I am most grateful.

CONTENTS

First published 1980 in the United States and Canada by Watson-Guptill Publications,
a division of Billboard Publications, Inc.,
1515 Broadway, New York, N.Y. 10036

Library of Congress Cataloging in Publication Data
Shackelford, Bud, 1918–
 Experimental watercolor techniques.
 Bibliography: p.
 Includes index.
 1. Water-color painting—Technique. I. Title.
ND2430.S52 1980 751.42′24 80-36663
ISBN 0-8230-1619-6

Published in Great Britain by Pitman House,
39 Parker Street, London WC2B 5PB
ISBN 0-273-01622-9

Manufactured in Japan

First Printing, 1980

To my wife Dot and to my children
Chuck, Leigh, Jeanie, and Todd

INTRODUCTION

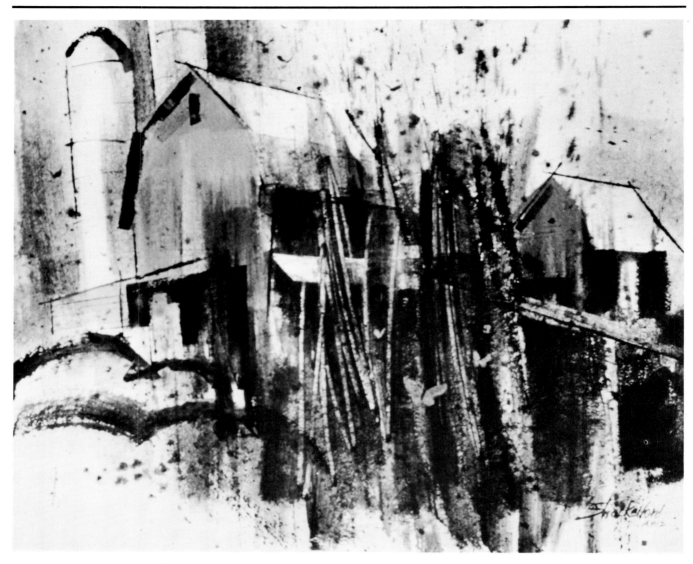

Two Barns, *by Bud Shackelford.* This vigorously animated painting is accomplished by *leaning* all the major structures to set up a tension, and boldly painting and scratching out the huge grasses running up between the two barns. While the paper is still moist, spots of pigment are flung off a brush from the grass area into the sky. The procedure is to moisten the entire sheet first and add the light tones in the sky and foreground, then immediately paint in the grass masses. During drying stages, the barn structures are painted in with darks appearing here and there through the grass. Tones are added in the sky area only where needed to make roofs and silos appear lighter in contrast. Strong angular tensions in the barns are offset with massive, roundish curves suggesting plowed fields and a heavy, bold, round silo cover. When the painting is dry, very thin lines overlapping in places, or slightly off-register, are crisp, spontaneous additions. These are applied with mat board edge stampings, one of the experimental techniques described in a later chapter. Last of all, the butterflies are painted right over the grass with cadmium yellow deep. (All the cadmium colors are opaque enough to accomplish this without adding white pigment.)

Experimental Watercolor Techniques is a book for the watercolorist who wishes to create paintings with strength and spontaneity or who is searching for new ideas, new approaches, and useful tips and creative processes. It's a workshop experience in creative painting, with eight chapters on how to loosen up and paint with vigor and substance.

First we'll explore modern painting theories and basic principles for achieving strong design. Then we'll discuss the materials and equipment you'll need, and examine the equipment I've designed and built over the years to serve my own needs in the studio and to make my outdoor equipment light, compact, and simple. Included are detailed photographs and descriptions for constructing such equipment as a stay-moist watercolor palette; a small pocket palette; soft-surface, lightweight mounting boards; special water containers; and lightweight portable easels made from inexpensive, well-engineered camera tripods. The tripods are quickly assembled or folded and can be carried with other portable equipment in a specially designed canvas bag. Tips and ideas for setting up your own studio are also included.

After these two introductory chapters, eight chapters on modern, exploratory techniques follow: working with wet-into-wet techniques; experimental stamping techniques using textured materials; edge and flat stampings with mat boards; lift-off and scrape-out techniques with a variety of materials; surface effects through paper torture (folding, creasing, crushing, burnishing, sanding, and scratching the paper surface); using masking tapes and liquids and resists to control the paint flow; and using splatter and sparkle in your paintings. Each chapter is written and illustrated in an easy-to-understand way and contains an explanation of materials and tools for producing these exciting textures and effects; examples of each technique, with variations applied on both wet and dry paper; simple illustrations showing how each texture or surface effect can be applied to a subject; valuable tips to help you perfect each technique for the best results; interesting assignments for you to try; an exciting, step-by-step, full-color demonstration painting with detailed explanations of procedures used in painting it that tie in with the theme of that chapter; and examples of paintings by various artists using these techniques. Each chapter also reviews important design principles, composition and space-division theories, color tips, methods of planning negative and positive shapes, push-pull theories, ways to add life to a painting through tension and distortion, plus many other tips.

The final chapter reviews the information you've learned on color and color theory, abstracting from realistic reference material, and using experimental texture techniques. Large, double-spread paintings follow, with "callouts" pointing to specific techniques used in the painting. A number of valuable tips are given on framing and exhibiting your paintings and on keeping a filing system of your work, and the questions most often asked in my workshops are answered.

As you'll discover after reading this book, if you give watercolor half a chance, it will do amazing things for you. Now let's enjoy thethe real fun of watercolor!

MODERN THEORIES

Today we see experimentation in painting everywhere, from totally new, inventive ideas to cleverly handled painting of illusions and sensations. The serious watercolorist of today must pack a lot of substance into his work through strong design, exciting color and texture passages, distortions, and tensions to create paintings that are vigorous and alive. The quiet little scene seldom competes with the dynamic works of today.

There are two basic approaches to painting nature, the methodical and the creative. In the methodical approach, all the parts of the painting, starting with the composition, are carefully planned in advance. First, in a pencil drawing, the subject is developed in three dimensions, with the proper proportions and perspective noted. Then the colors are carefully matched to the actual subject, and the painting is developed with attention to the light source, modeling, and realistic detail. Many fine painters, with their own styles and variations, work in this method.

In the creative ("just let it happen") approach, the image develops as you paint. It may start with a quick, vigorous sketch in pencil or an impression scratched on the paper or with the subject only in the artist's mind. Here less attention is given to modeling three-dimensional forms, light sources, or perspective. Usually the shapes and forms are flat, overlapping patterns. The subject emerges as lively strokes are applied with the brush or with experimental methods later described in this book.

Exciting things can happen when rich pigment is applied to wet paper. For example, vibrant textures can be pressed into the paper with paint on textured materials, while other creative processes produce rich surface effects. Tension and distortions add life and activity. At any rate, each painting is a total surprise and therefore extremely invigorating to the painter. Artist Paul Klee once wrote, "The artist may be surprised at his own discoveries. Artists know a great deal, but only afterward. You cannot start with a result."

The creative approach to painting is an outgrowth of the Impressionist period and has stimulated exciting changes in art, freeing painters to explore new fields of creativity and inventiveness.

The Perspective Trap

Much about the creative approach can be learned from Paul Cézanne, a post-Impressionist and the father of modern painting. Cézanne discovered in the traditional drawings and paintings a problem he called "the perspective trap." In traditional one-point perspective, all lines converge to a single point on the horizon, leaving the viewer trapped in the far distance (top). To solve the problem, Cézanne took liberties to narrow the depth of field by flattening out extreme perspective in roads and buildings, enlarging distant hills and bringing them forward with warmer colors, and introducing flatter, overlapping shapes and forms. These overlapping forms were arranged to recede for a limited distance to the background and return on the other side to the foreground (bottom).

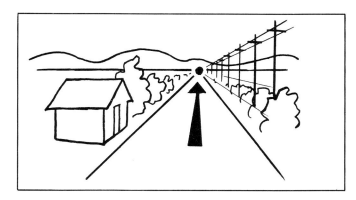

He also added life to his paintings through subtle distortion, giving animated qualities to otherwise static forms; he set up surface tensions with clever modulations of warm and cool colors; and he was able to completely control his depth of field. Many of his paintings have a beautifully designed and composed flat-patterned look that has become one of the keys to today's strongly designed and patterned painting. By eliminating deep perspective and returning to surface qualities, Cézanne realized that much more emphasis could be applied to dynamic design, pattern, and surface textures and tensions. His experiments led to Cubism, Expressionism, and other outgrowths in many directions, and eventually resulted in present-day painting trends.

You can study Cézanne's work further in a book called *Cézanne's Compositions*, by Erle Loran (see Bibliography). I also suggest that you study the major painters of the Impressionist and post-Impressionist periods, the German Expressionists for color experimentation, and the tensions and distortions of the American artists John Marin and Lyonel Feininger. Discover your library!

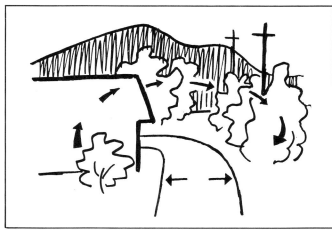

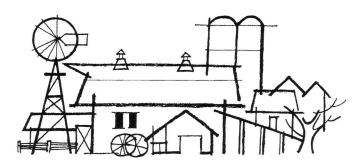

Space Division

Using Cézanne's theories of flattened perspective as a guide, we can now concentrate on designed space divisions. Pictorial space is divided horizontally, vertically, diagonally, and curvilinearly.

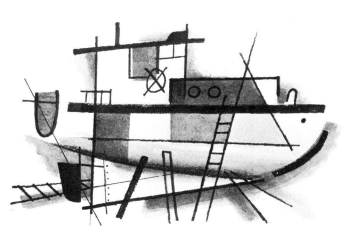

Unequal Divisions. For the most pleasing composition, these divisions should be *unequal*. You can create tensions with diagonals and add relief to angular divisions by adding curves. Large space divisions can be further broken down into smaller shapes and forms, keeping the overall balance in mind. Selecting side, top, or front views of the subject lessens the problems of perspective and reduces the subject to flatter patterns.

Flattened Space

With less dependence on deep-space perspective and three-dimensional modeling, you now have complete control of depth of field and can manipulate the painting to make shapes advance or recede at will. One way of doing this is by overlapping shapes to further suggest position in space. Since warm colors advance and cool colors recede, positive shapes can be brought forward with warm colors and negative passages pushed back with cool colors. These movements are called "push-pull." Thus, when a cool-colored area is placed next to a warm-colored area, the cool area appears to be behind the warmer-colored one. In the case of overlapping shapes, if you place a cool tone on the more distant shape that goes to the edge of the forward shape, you can suggest a spatial passage or separation between them.

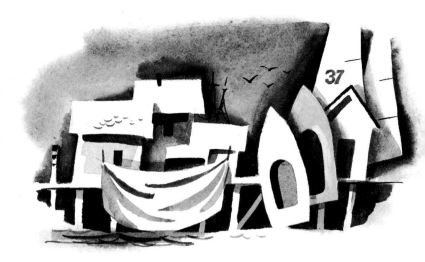

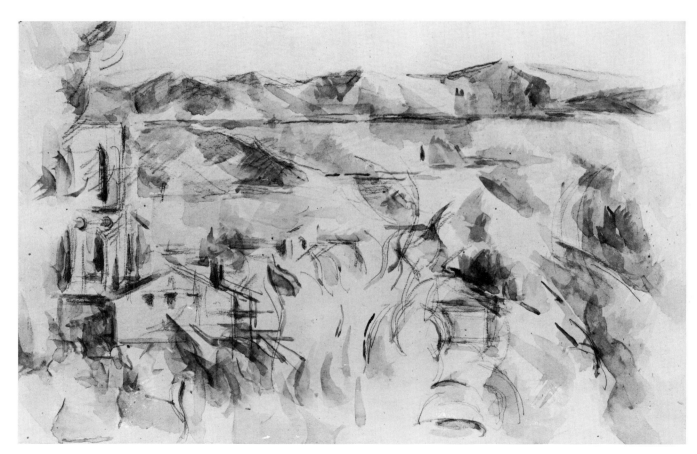

View of the Cathedral of Aix, by Paul Cézanne. Watercolor, 1904–1906, 12″ × 18½″ (30.5 × 47 cm). *Philadelphia Museum of Art, Arensberg Collection.* With the advent of this "shallow modeling" of shapes and forms that was developed in the post-Impressionist and Cubist periods, forms could now be subtly shaded and modeled without regard to a light source. Thus the artist was no longer dependent upon the laws of nature and lighting to create. He could turn an edge, shape a form, or tone a spatial passage between forms wherever he wanted. The camera could never do this!

Creating Moods Through Design

Exciting compositional designs can be made with variations of horizontals, verticals, obliques, and curves. Basically, these themes are a starting point of reference from which the creative painting emerges. (You may even recognize some of them as the basis for several of the paintings reproduced in this book.)

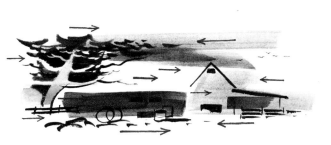

Horizontals. A composition with the emphasis on horizontal lines suggests wide expanses and restful, peaceful moods.

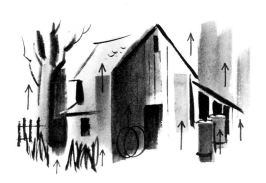

Verticals. When the emphasis is on verticals, on the other hand, the composition suggests tall objects and stately, monumental moods. A combination of verticals and horizontals suggests architectural themes.

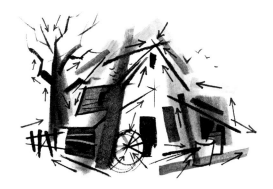

Diagonals. Angles and obliques appear to be in conflict and thus create tension in a painting.

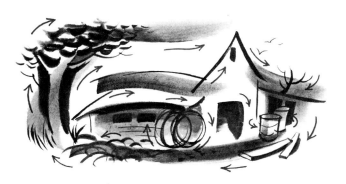

Curves. Curves suggest organic movement and sensuous moods. By varying or combining these design elements, you can create numerous other moods and symbolic suggestions.

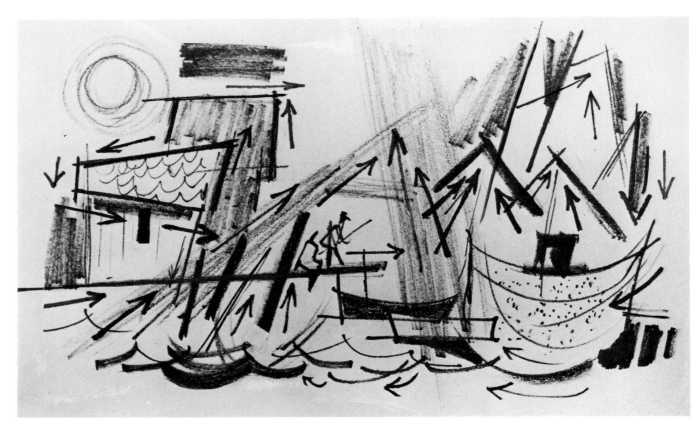

Tensions and Distortions

Why are some paintings so dull and monotonous? One reason is that they lack life. They may be static and without energy. In photography, to counteract this, cameramen often seek extreme angles to produce more exciting photographs. But the artists have it all over photographers because at will they can distort and create thrusts and angles or movements and tensions to animate their work and bring it to life.

The extreme thrusting of forces in my painting *Wharf Tensions* illustrates one way this can be done. The painting relies heavily on angular conflicts offset by curved movements to bring it to life. Notice that the sheds are distorted to create shifts and tensions. The arrows show the forces and tensions that set up movements and conflicts. There is a major movement of oblique tones from the lower left to upper center, meeting in conflict an opposing angular tone, causing a triangular configuration. Strong triangular roofs moving to the right repeat these forces. The negative sky passages also act as strong forces that set up the sail patterns and lead the eye down through the massive curve of the net and repeated curves of the water surface. Pilings are tilted to oppose the angles on the right, as are the sheds on the left. Strong abstract accents over the roof and under the pilings strengthen those elements. Using accents to focus attention on an area was one of John Marin's favorite devices.

Right
Most modern painters have used distortions and tensions in varying degrees for various purposes. John Marin, the great American watercolorist and teacher, is best known for his use of these distortions and tensions in his landscapes and seascapes. Can you feel the sensations in these two examples?

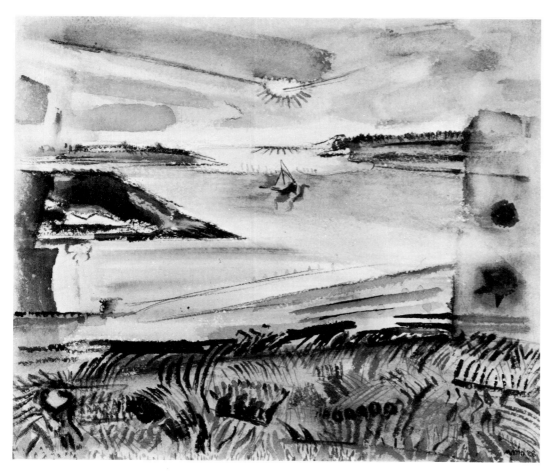

Sun and Gray Sea, Small Point, Maine, *by John Marin. Watercolor, 1949, 14⅜″ × 16 15/16″ (37 × 43 cm). The Metropolitan Museum of Art, Stieglitz Collection.*

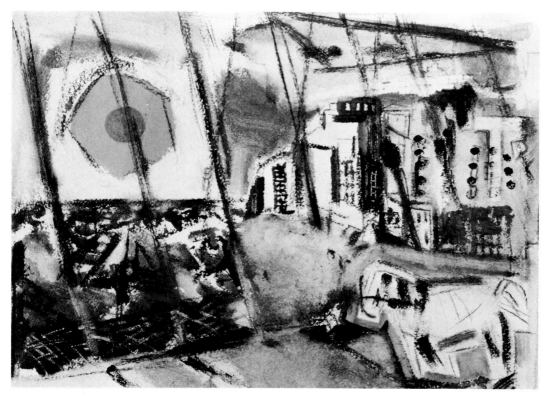

The Red Sun, Brooklyn Bridge, *by John Marin. Watercolor, 1922, 21⅛″ × 26″ (54 × 66 cm). The Art Institute of Chicago, Stieglitz Collection.*

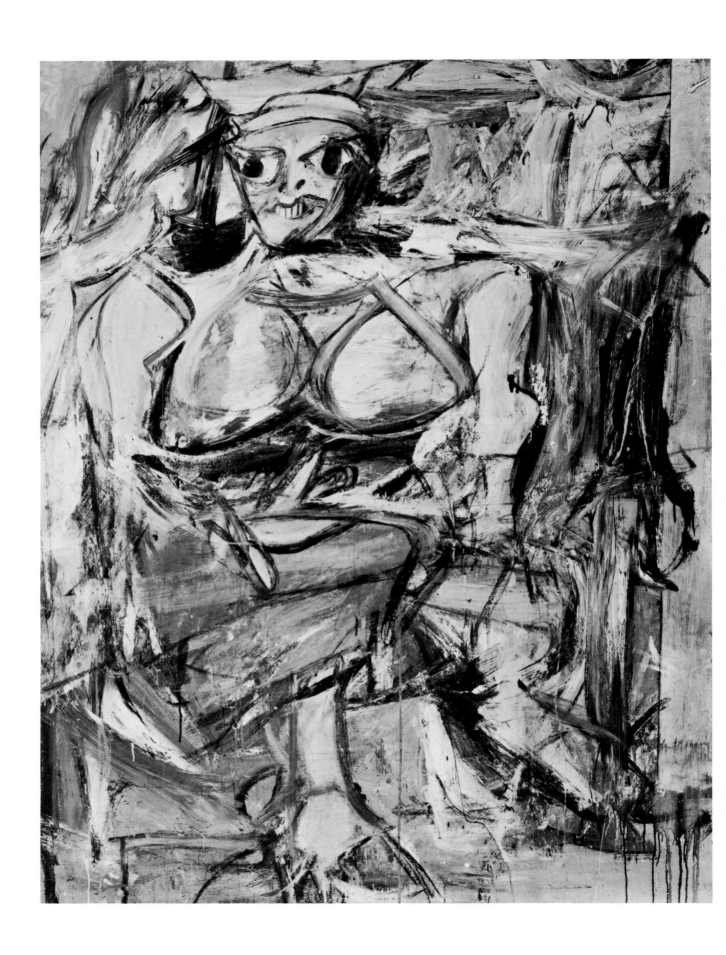

Above
Beached Ferry, *by Bud Shackelford. Collection Robert Hiram Meltzer.*
As artists worked with space divisions and flattening the depth of field, the stage was set for exploring surface effects and textures. In recent years there's been an upsurge of experimental methods for creative exciting happenings on the surface of the paper. (Collage, which also started in the Cubist era, was one such outgrowth of surface experimentation.) In the chapters that follow we will examine experimental techniques you can use to add interest and texture to the surface of the paper.

Left
Woman I, *by Willem de Kooning. Oil on canvas, 1950–52, 6′ 3⅞″ × 58″ (190 × 147 cm). Collection Museum of Modern Art.*
Figure painters have also used subtle distortions in their paintings to create a sensation of movement or life. Pablo Picasso was one of the greatest inventors of distorted shapes and forms. As you can see in the example above, Willem de Kooning also used tensions, conflicts, and distortions in his figures, but in a different way from Picasso.

MATERIALS AND EQUIPMENT

Here is a description of the materials I use in my work. I have designed much of this equipment myself, so it suits my needs exactly! Perhaps you might try making your own equipment too.

For best concentration, I do my serious painting in the studio, where there's no wind, sun, or cold and where I'm surrounded by soft, inspiring music. For your studio, I suggest that you buy a comfortable swivel chair and set up good lighting, with the window on your left (if you're right-handed). Your table should be substantial, adjustable in height, and able to be tilted up or down. I built an adjustable extension on the far side of my table that conveniently holds my reference sketches right in front of me.

Your taboret should be a comfortable working height, since it will hold your palette, brushes, water container, and other materials. Besides a taboret, I also have a small, low table on my left, with a partitioned shallow box for all my stamping and texture materials and with drawers for tubes of paint and other extras that aren't kept in the taboret.

For most techniques described in this book, 140-lb cold-press handmade rag paper is best. The 300-lb paper can also be used, but it's expensive and dries more slowly, which reduces your spontaneity. However, 70-lb paper is too thin; even in half sheets, it's subject to buckling if it hasn't been prestretched. I prefer either Strathmore Gemini 140-lb or Arches 140-lb paper, both with 100% rag content. The new Aquarius II nonbuckling rag paper recently developed by Strathmore also works well in these techniques. It is soft to the touch and has no Fiberglas. You'll be surprised at the amount of water and pigment this amazing paper can take and still lie flat.

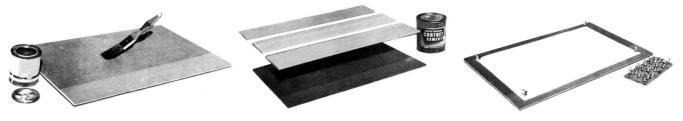

Lightweight Mounting Board

With few exceptions, I no longer prestretch my paper. It's more fun and more spontaneous to skip this step. I use ½" or ⅝" (13 or 16 mm) pushpins on a soft balsa surface to hold the paper in place. I place one in each corner and tighten the paper as it expands. When drying, the paper shrinks, so I simply push pins into it 4" (10 cm) apart all around the paper (pushing into the soft balsa) to keep the paper taut.

A full-sheet board should be 24" × 32" (61 × 81 cm), and a half-sheet board, 17" × 24" (43 × 61 cm). A quarter sheet, which is 13" × 17" (33 × 43 cm), is used with my outdoor pocket equipment and a small tripod easel.

I constructed the board by gluing 8" × ¼" (20 cm × 6 mm) lengths of balsa (available in model and hobby shops) together over mahogany plywood ⅛" (3 mm) thick, using waterproof contact cement. Then I sanded and finished the wood with two or three coats of exterior varnish or shellac to waterproof the absorbent wood. An extra piece of balsa makes a great holder for your pushpins.

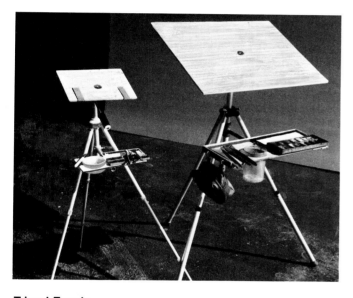

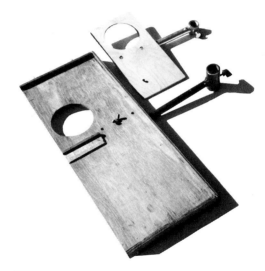

Tripod Easels

Beautiful fully adjustable, lightweight aluminum tripods are available in photography supply stores. Since they've been well engineered and manufactured in large quantities, making their prices very reasonable, I take advantage of this and, through a simple conversion, make them into painting easels.

My two easels are pictured here. The more substantial tripod is designed for half-sheet or full-sheet mounting boards; and the smaller tripod, for a quarter-sheet board or sketchpads. To make the easels, I attached the mounting boards previously described to the standard tripod bolt with a thick threaded washer and tightened the bolt from underneath, just as I'd mount a camera. I routed the washer hole in the board to recede the washer flush to the surface. I fashioned two metal clips (to hold the cardboard backing of top-bound sketchpads) to the smaller board. Bristol paper pads have an interesting, slick surface for permanent-ink felt-pen sketches and color-tint overlays. All my pocket equipment goes with this easel, including cut-down brushes, which I carry in a small leather holster on my belt. My tripod was purchased with a zippered carrying bag and strap handle.

Tripod Trays

The secret of my engineering is a slip-on tray that requires a little welding. (Any welding shop can do it.) A length of ½" (13 mm) pipe is welded to a 2" (5 cm) length of pipe, which fits the centerpost of the tripod. This pipe is threaded for a tightening bolt, and the ½" (13 mm) pipe is drilled for bolts and nuts to fasten the wooden tray on. The small tray measures 5" × 10" (13 × 25 cm), and the large tray is 8" × 20" (22 × 50 cm); both trays are made of ¼" (6 mm) plywood. The larger tray also has a horizontally welded metal flange for extra support under the wooden tray, including the bolt welded in place. A wing nut is used over the bolt. I also cut several small holes into the tray to adjust it to several sizes of mounting boards and cut larger holes out of the tray to fit the tapered freezer-jar water containers previously described.

The palette is placed on the right-hand side of the tray, where there's extra room for brushes and other materials. To attach the dry-pigment pocket palette, I drilled a hole through the center of the palette (see photograph of pocket palette) and secured it to the tray with a thin nut and bolt. I wedge the larger palette onto the tray with the small strip of wood shown in the photograph. A small zippered satchel for stamping and other materials hangs off two hooks on the left. (The full setup can be seen in the tripod photograph.) With practice, you should be able to set up a similar rig in minutes.

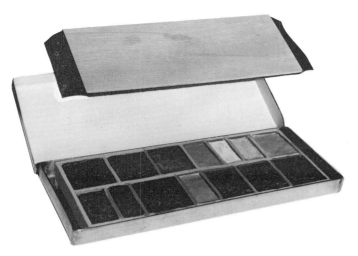

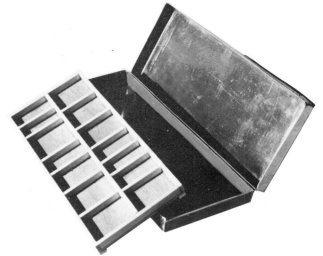

Stay-Moist Palette

My "stay-moist" palette is a specially designed homemade palette that rests in a 3½" × 8¼" × ¼" (9 × 22 cm × 6 mm) brass box, shaped in a vise. The lid works with a soldered piano hinge. The paints lie in a plywood paint holder that fits snugly into the brass box on two sides but is cut 1" (25 mm) narrower than the brass box on the other two sides, leaving a ½" (13 mm) space on each of these sides for two wells (see photograph). The palette rests on two thin basswood strips. At a model airplane shop I purchased the strips and plywood ⅛" (3 mm) thick for the base and glued the strips to the base with waterproof contact cement. (White glue won't hold!) Then I sprayed the inner lid with several coats of white gloss enamel paint for the color mixing area. Finally I glued a strip of felt to a ⅛" (3 mm) plywood stiffener (the size of the wooden palette area). I overlapped the felt on both sides and placed the flaps in the water wells. The water is drawn up into the felt by capillary action, as in a blotter, and moistens it. When I'm through painting, the lid covers the entire set.

How It Works. Water poured into the water wells seeps under the raised wooden unit and transfers moisture to the pigments from

below. The felt cover that rests on top of the paints picks up the moisture from the flaps in the water wells by capillary action and keeps colors moist on top. Experience will show how moist to keep the felt; the moisture needed will depend on weather and frequency of use.

I also keep handy a water bottle with an atomizer to spray mist over the colors when working outdoors in the sun or whenever the colors appear to be drying.

Color Areas. The areas formed by the plywood partitions in this palette vary in size and are filled with colors squeezed from tubes. The largest areas are for my most frequently used colors, and the smaller ones for the less often used pigments or for dye colors that have tremendous spreading power and therefore require only a small amount of paint.

Colors. (Left to right, top) Burnt umber, burnt sienna, raw umber, new gamboge, cadmium yellow light, cadmium yellow deep, and cadmium orange. (Left to right, bottom) Winsor red, alizarin crimson, ultramarine blue, cerulean blue, phthalo blue, viridian green, and Hookers green.

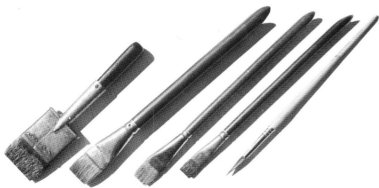

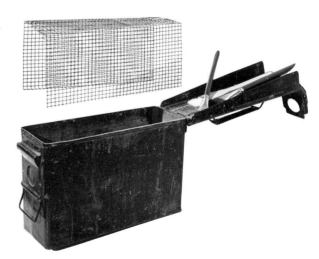

Brushes

It pays to buy good brushes. Your selection should include four or five (see photograph above, left to right): (1) A flat oxhair 1½" or 2" (4 or 5 cm) brush for initial wash-ins. (2) A 1" (25 mm) flat chisel brush with good "snap back" and a tapered handle for scrape-outs; I prefer the Aquarelle brush. (3) Also ¾" and ½" (19 and 13 mm) Aquarelle brushes. (4) A top-grade no. 8 or 10 pointed round sable brush. I prefer a Strathmore Kolinsky sable watercolor brush; it has a clear natural-wood handle (no paint cracking) and the finest "snap-back" pure Russian sable, which always comes to a sharp point, a necessity for spontaneous crisp detail and linear applications. It's expensive, but well worth the price and will last for years.

Studio Water Container

For the studio, a 30-caliber ammunition box (available in army surplus stores) makes an excellent water container. It has a sealed lining cover that latches watertight. When open, the cover can be used to hold brushes. I shape and fold a heavy screen (hardware cloth) to fit below the water level; it is handy for rubbing excess pigment off the brush.

OUTDOOR EQUIPMENT

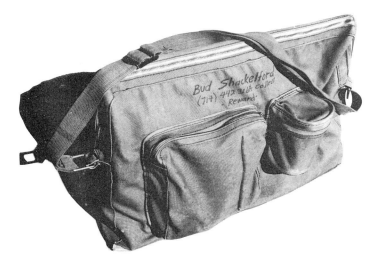

Canvas Carrying Bag

An awning company stitched up my heavy-duty canvas bag from sketches I'd made. It fits my mounting board and papers, and all the tripod easel parts go inside the large section. The water jar fits inside an outside zippered pocket, and my brushes are in a round leather case inserted into the vertical stitched pocket to the right of the outer rectangular zippered pocket. The satchel with stamping materials and extras is in the square pocket. I even have room for sweaters, small folding stools, and other extras. An adjustable strap completes the bag.

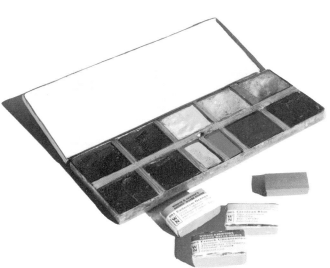

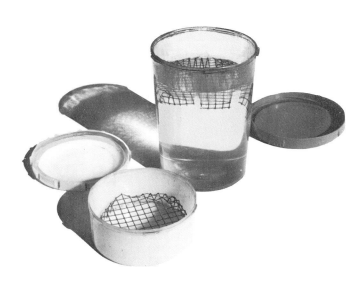

Pocket Palette

The pocket palette is a dry color palette I use outdoors. The brass shell measures 2½″ × 6½″ × 5/16″ (4 × 16.5 cm × 9 mm), and the basswood partitions are glued in place on the brass. I use Winsor & Newton full-pan colors, combining two pieces of the same color to a space for the colors I use most. They're glued into place with contact cement. Since the colors are slightly tapered, I reverse one against the other. This little set supplies a surprising amount of rich color for quick paintings on location.

Colors. (Left to right, top) Burnt umber, burnt sienna, new gamboge, cadmium orange, and cadmium red light. (Left to right, bottom) Alizarin crimson, ultramarine blue, cerulean, phthalo blue, viridian green, and Hookers green.

Outdoor Water Containers

For on-location painting, lightweight plastic freezer jars are perfect, because the lids are watertight. I cut hardware cloth with tin snips in a circle wider than the jar, then snip the edges inward and bend them down to wedge into the jar. The smaller jar is pocket size, to go with the pocket palette.

CHAPTER ONE
WET-INTO-WET

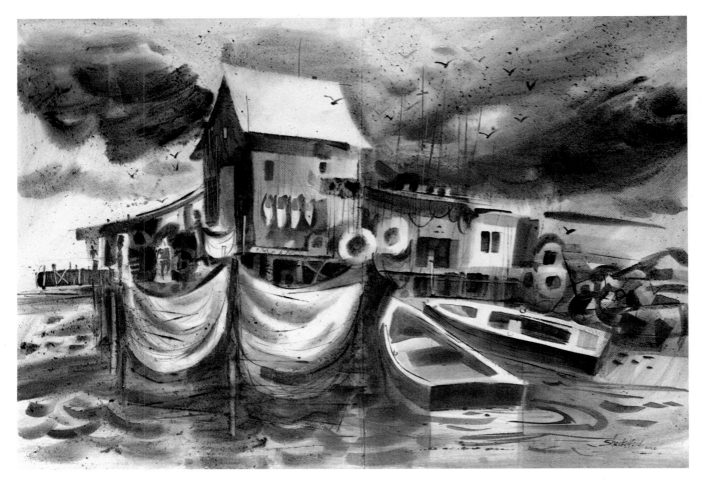

Fishing Pier, *by Bud Shackelford.* The subject of this painting, an old fishing pier in the bayous of southern Louisiana, set up a strong composition of overlapping forms with curves, angles, hard edges and soft edges, and a variety of shapes and sizes. Wet-into-wet techniques were used here to create fused masses of clouds, soft folds in the nets, wet effects of water, and a variety of soft edges in contrast to crisp edges. For instance, the fused circular brushstrokes in the sky contrast with the sharp, angular edges of the roof and shack below. Working storm clouds into a wet surface can be very exciting, because something different happens each time. I usually start with medium tones and work them into the sky with curved sweeps. Then, with thicker, drier pigment, I twist the brushstrokes in circular movements to create the dark, storm-cloud effects. The moist paper causes the pigment to blend. Most of the fused parts of the painting were created during the early stages of painting when the paper was still moist; crisper parts were added during the stages of drying. Final details, such as the birds, floats on the side of the building, the little fisherman, poles, and oarlocks, were painted in with a fine brush.

Fun things happen when rich watercolor pigment is swooshed, scum-bled, or dropped onto a wet surface. This chapter will introduce you to the amazing possibilities of wet-into-wet watercolor painting, the characteristic that makes the medium so exciting.

When a brush charged with paint is applied to moist paper, a brilliancy is created by the reflection of light off the white paper through the translucent colors, and wonderful glows and glazes are produced. (This is later enhanced when the watercolor is framed behind glass.) Watercolor pigments also blend in beautiful ways when applied to moist paper, because of the paper's ability to absorb and fuse them. This is a big advantage over other mediums—oil, acrylic, and casein—that are applied to nonabsorbent surfaces such as primed canvas, Masonite®, plywood, and other hard grounds. With these mediums, blending is accomplished by special brush handling and other means, and the results are less spontaneous and more controlled.

In working wet-into-wet, it's important to gain experience in brush handling and to become familiar with controlling pigments in moistened areas. Different effects are created when diluted pigment is applied to wet paper, when thick rich pigment is used on wet paper, or when thick or thin pigment is applied to drier areas. Other effects are created through brush handling, such as stroking, scumbling, twisting, and dabbing.

MATERIALS AND TOOLS

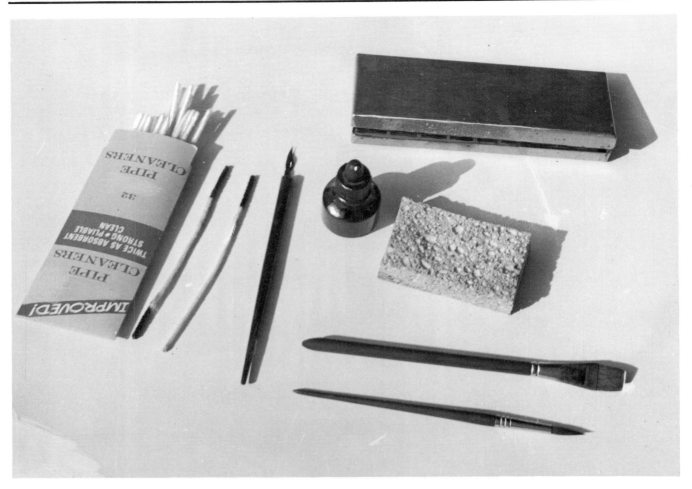

To practice the examples in this chapter, you'll need a ¾" or 1" (19 or 25 mm) flat brush (Aquarelle or similar), a high-quality no. 8 or 10 pointed sable brush, your watercolor palette, a kitchen-type sponge, India ink, pipe cleaners, and a straight pen with a medium point.

This also would be a good time to try watercolor papers with a variety of surfaces—cold press, hot press, and plate finishes—to give you a range from rough to very slick surfaces. I used a 140-lb cold-pressed 22" × 30" (56 × 76 cm) full sheet for these examples and cut it into nine pieces, each 7½" × 10" (19 × 25 cm).

The following exercises will help you get started with the real fun of watercolor. Things begin to happen as soon as wet pigment hits wet paper, so get set for surprises, because wet-into-wet paintings never come out the same way twice. With a little practice, you can make these happy accidents work for you, and if you do enough quick paintings, you'll get some gems!

APPLICATIONS

Handling Wet-into-Wet. Moisten the front and back of the paper with the sponge, and mount the paper on the board with a pushpin in each corner. Then, select a color (I used burnt umber for the first five examples), and using your ¾″ or 1″ (19 or 25 mm) flat Aquarelle brush, mix enough water into the pigment to get a medium tone. Now swoosh the tone over the wet surface from left to right; it will fuse with the water on the paper automatically. Next dip the brush into thicker, richer pigment; then twist and turn it into the first wash from right to left, using the side of your brush for a thinner line, and let it trail off for variation. You'll notice that the edges will continue to fuse in interesting ways and that the pigment will be much darker. If the paper shows any signs of buckling, lift the pins at diagonal corners, pull the paper taut to the corners, and reapply the pins. Repeat at the other diagonal corners. Finally, while the surface is still moist, lightly dab or tap the corner of the richly loaded brush on the paper for fused dot effects. Depending on shapes created, these applications can become turbulent skies, smoke, mountains, masses of foliage, distant trees and shrubs, or whatever else your imagination allows.

Longer Strokes, Wet-into-Wet. Moisten the front and back of the paper with the sponge, and pin each corner as before. With the same flat brush and a light tone of diluted pigment, suggest cloud shapes with circular strokes. Next, dip your brush into richer, thicker pigment and go over the undersides of the clouds with short concave strokes. Then pick up your pointed sable brush, dip it into rich pigment, and repeat a few smaller concave strokes. (You may have to rewet the lower portion of your paper with the sponge.) Now, with plenty of pigment on the pointed sable brush, swing it in long strokes from side to side. These fused washes are useful for expressing such things as long stretches of clouds, waves and water surfaces, and—with variations of these strokes—distant fields of grass and grains.

Wet-into-Wet: Grass and Trees. This is an exercise using your pointed sable brush and watercolor. First, wet both sides of the paper with the sponge, and pin all four corners. We'll start with the tree foliage. Mix a medium tone of diluted pigment, and apply with the side of the pointed brush in short U-shaped strokes. Now dip into richer pigment, and holding your brush more nearly upright, apply more massive strokes to the underside of the foliage. Switch to shorter dab strokes (little side-to-side strokes with the point upward) around the perimeter of the trees at the top right and lower portions. You now have interesting fused variations of tones and sizes. If the paper is dry, rewet the lower portion with the sponge. Then apply the grass impressions with upward strokes of the pointed sable brush, using a medium tone first and changing to richer, drier pigments later. Notice the slight variations in direction of these strokes and that each trails off to a point at the end. The crisp, dark tree trunks and branches and the grass are applied on completely dry paper. This creates an interesting contrast between hard-edged shapes and fused shapes.

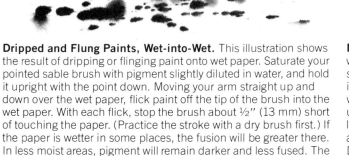

Dripped and Flung Paints, Wet-into-Wet. This illustration shows the result of dripping or flinging paint onto wet paper. Saturate your pointed sable brush with pigment slightly diluted in water, and hold it upright with the point down. Moving your arm straight up and down over the wet paper, flick paint off the tip of the brush into the wet paper. With each flick, stop the brush about ½″ (13 mm) short of touching the paper. (Practice the stroke with a dry brush first.) If the paper is wetter in some places, the fusion will be greater there. In less moist areas, pigment will remain darker and less fused. The pigment in the lower portion was flung off the brush in a fast flick from left to right.

You might also try flicking pigment off a toothbrush onto a wet surface. This creates many more spots with each flick. Moisten the toothbrush with water, dip it into the pigment, and mix it on the palette first, to get an even consistency. You can raise the toothbrush a little higher above the paper for more widely scattered dots or move it closer for a concentrated spotting. Fused spots are useful for such items as masonry textures, foreground earth textures, ruts in earth and dirt roads, trees and shrubs on distant hills, and foliage textures.

Drawing Wet-into-Wet. In this exercise, you draw on a wet surface with a pointed sable brush and thick, rich pigment. Try all kinds of strokes and movements on several different types of surfaces, including rough, dry press, hot press, and plate finish. Calligraphy with fused variations has many uses in painting. Wherever lines are used to define objects, to create shapes and forms, or to suggest linear textures, it's advisable to vary them between crisp and fused applications. Study the work of the famous French painter Raoul Dufy, who used line so effectively.

Handling India Ink. For real fun and surprises, try black India ink on a wet surface. Results are more effective on slick surfaces like Bristol board or plate-finish papers. When ink touches a wet surface, it crawls out in a spidery way, as shown in this example. In the heavier version at top, the paper was quite wet and the fusion spread out instantly from a full pen point. Less ink and drier paper causes the ink to spread more thinly. The two spots were made with a loaded ink point touched to a moist area. All the shapes at the bottom were applied with a pipe cleaner dipped into India ink and dragged up and down with slight variations. The squiggly outshoots just "happen" as the ink crawls into the wet areas. Turned upside down, they appear to be stubby trees with scraggly branches.

TIPS

1. Watercolors dry lighter than when applied, especially when applied wet-into-wet, since the paper absorbs some of the pigment. Compensate by overpainting on the darker side.

2. Your pigments should be fresh and moist for those thick applications in wet-into-wet areas. You can't paint spontaneously with caked and dried-up pigments.

3. Don't try to rework a fused area when it has partially dried. The moisture will cause watermarks and ruin the passage. Let it dry completely, then rewet the area, tapping it with a moist sponge or spraying with clear water from an atomizer, and continue painting wet into wet.

4. Often, a wet-into-wet passage can be completely washed off with a wet sponge if it doesn't turn out to your satisfaction. Do this before it has dried. Immediately try again.

5. A partially dried hard edge can be softened and fused with a brush moistened with clear water.

PROJECTS

1. Using a mixture of raw umber and ultramarine blue on a half sheet of watercolor paper, develop a large, wet-into-wet stormy sky over a low range of mountains. The sky should occupy three-quarters of the composition. Develop the hills in dark silhouette when the paper is nearly dry. The dark, flat, hard-edged hills should contrast with the massive, fused cloud formations.

2. On a half sheet, with mixtures of new gamboge (yellow) and burnt umber, develop a large foreground field of golden wheat blowing in the wind using wet-into-wet techniques. When dry, add trees, buildings, and silos in the background. Try to get a feeling of movement in the wheat field with fused pigment and grassy texture.

3. Working on a half sheet of plate-finish watercolor paper or slick Bristol board with black India ink, a straight pen, and pipe cleaners, develop a composition of huge rocks and boulders in a massive foreground. Wet the paper, dip the pipe cleaner in India ink, and begin by outlining the shapes of the large foreground boulders. For the smaller rocks in the distance, use the straight pen and ink. Add scrubby shrubs here and there, using the spidery effects of ink drawings in the wet areas. On top of the rock foundation, add a small lighthouse or mission right of the center. When it's completely dry, diluted watercolor can be brushed over the surface for color glazes of your choice. Leave some white paper showing for sparkle.

DEMONSTRATION

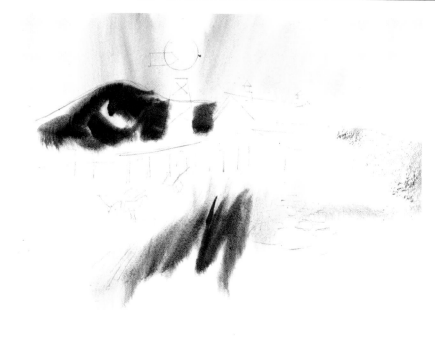

Step 1. The barn composition was developed from several different thumbnail sketches. I draw it in pencil on a full-sheet 140-lb cold-press watercolor paper. Although the paper can be prestretched by soaking it in water and mounting it on a board with 2″ (5 cm) gummed tape around the border (it will pull tight when dry), I prefer to wet it thoroughly on both sides and pin it tightly on all four corners with pushpins to my balsa mounting board. As the paper dries and begins to shrink, I set pushpins 4″ (10 cm) apart all around the edges. The paper gets taut as I'm working on it.

When the paper is moist all over (no puddles), I begin adding light washes. I moisten all brushes before I start. Using a 1½″ or 2″ (4 or 5 cm) flat brush and a diluted mixture of new gamboge with a touch of raw umber, I paint the sky, fusing a little of the color into the grass, and into the mountain area to unite it with the sky. Next, dipping one side of the brush into rich, thick burnt umber and the other into raw umber, I twist and twirl the brush into the mountain. Then I dip a smaller ¾″ or 1″ (19 or 25 mm) flat brush into a mixture of rich burnt sienna with a touch of burnt umber. Holding the brush edgewise, I quickly suggest grass with vertical strokes. The hills on the right and the tone below the barn are washed in with a mixture of raw umber and ultramarine blue.

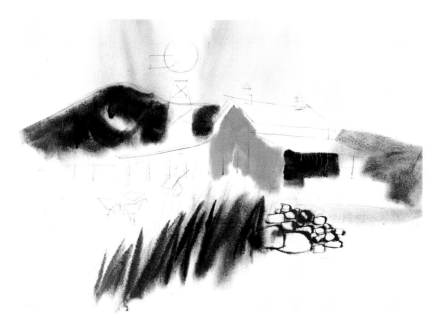

Step 2. In the moist rock area, I try to get spidery edge effects with the pen and black India ink. Then I loosely apply a mixture of cadmium orange and burnt sienna to the front and side of the barn, leaving a little white edge untouched to separate the two sides. Next, I wash a darker value of burnt umber with a touch of cobalt blue over the shadow (right) side of the barn. The runs that appear under the lower roof are caused by the tilt of my tabletop. I decided to leave them in. I also add a few more strokes of burnt umber to the grass area with the pointed sable brush.

Step 3. While the pigment is still moist, I scrape out posts in the shadow side of the barn and a long pole in front of the mountain with the tapered handle of the Aquarelle brush. (You could also use a stick or pocketknife.) I then spatter some dark umber below and on the rocks with an old toothbrush, creating some texture. The fine dot-textured spray in the area of the chickens is also done with the toothbrush. (To do it, I mix a diluted tone of umber on the palette with my toothbrush, aim the brush at the area, and draw my thumb over the bristles. Practice it on a scrap sheet first!) I add a light umber and new gamboge wash to the left-hand side for an impression of the fence, and as the paper becomes less moist, I add curved strokes of mixtures of burnt umber and cobalt blue to the hills on the right, up to the edges of the roof and barn (thereby defining the barn shapes). With the same colors, I paint in strong shadow separating the two roofs. A few thinner strokes of burnt umber are added to the grass.

Step 4. Since the paper is nearly dry, I must rewet certain areas, such as the massive tree and foliage, to continue to work wet-into-wet by tapping them with a moist sponge. Using the no. 10 pointed sable brush, I apply viridian green with a touch of burnt umber in little dabs and *U*-shaped strokes. I then work more massive curved strokes of thicker color into the main body of the foliage, adding tiny strokes around the left and upper edges of the tree. A diluted gamboge tone is added for a wall on the right, and I quickly scrape out trunks and branches from the wet wash with the tapered handle of the Aquarelle brush. I moisten the foothills and add a few dark spots to suggest sagebrush.

The paper is now quite dry. I paint the dark shapes of the open doorway and shed with a cool mixture (ultramarine blue and a touch of burnt umber) because cooler colors tend to recede. The objects inside the shed, including the figure with the cart, are left unpainted. I use a dry tissue to blot a spot in the doorway for a suggestion of light in the shadow. Finally, with the pointed sable brush, I paint the details. The windmill, chickens, and cart are done with umber; the figure, with a rich touch of Winsor red to isolate it; and the objects in the shed, with cadmium yellow deep and new gamboge with a touch of burnt umber. Notice how the cobalt blue has separated from the umber in the shadow side of the barn painted in the preceding step, a characteristic of that color.

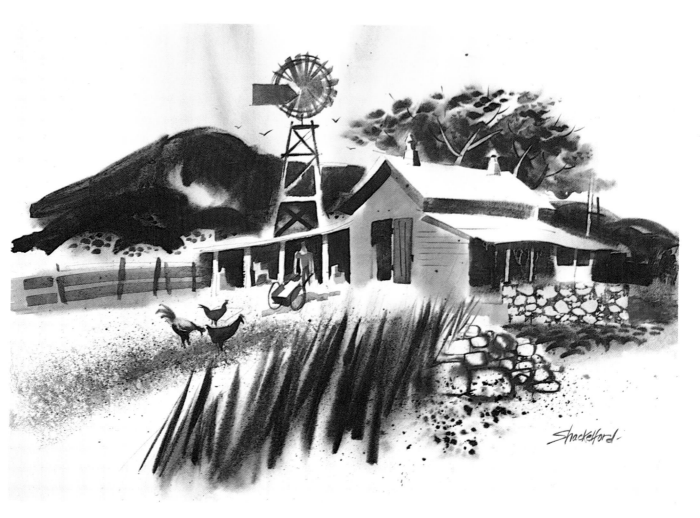

Barnscape. The reverse process is used to complete the super-structure of the windmill. While I previously painted as positive shapes the dark boards and braces silhouetted against the sky, for the remainder of the uprights and one diagonal, I now paint the negative spaces between the boards. For a change of pace, the lower negative space is painted in, blotted slightly with a tissue, and the *X* diagonal brace is painted dark against the lighter tone. An open door is added to the barn with a mixture of burnt sienna and burnt umber, and two flat, horizontal strokes are used to set up the fence on the left. I add stone pattern to the yellow wall, moisten the field below the wall, and suggest a plowed furrow texture with half-circular calligraphy, using the pointed sable brush and burnt umber. Final details, such as the fence posts and thin-board textures in the barn and roof, are applied with the pointed sable brush. Then I add a few shadows on the ground and more splatter near the chickens, and the painting is complete.

OTHER EXAMPLES

Maine Theme, *by Vivian Chevillon.* The calm mood of this beautiful watercolor was created with wet-into-wet techniques and restful, neutral colors (a limited palette of yellow ochre, burnt sienna, burnt umber, and manganese blue). In contrast to *Majestic Mission*, which explored energetic vibrations in rich pigments and "happy accidents," these colors were smoothly washed into dampened areas to create a quiet sky, water, and foreground. The board was tilted back and forth to precipitate the foreground wash area and to give it texture and more interest. The building, beach, and other objects were put in with a 1″ (25 mm) Aquarelle, with a small round brush used for the details. Some scraping was done with the brush handle and some stamping with a piece of cut mat board. The foreground is surprisingly devoid of detail, and just enough detail is suggested in the structures, buildings, boats, and lighthouses for an impression of these subjects. Much is left to the imagination. The foreground comes forward with warm colors, and the distant background recedes with cool colors. You can sense the wonderful translucency of the blended colors as the white paper glows through.

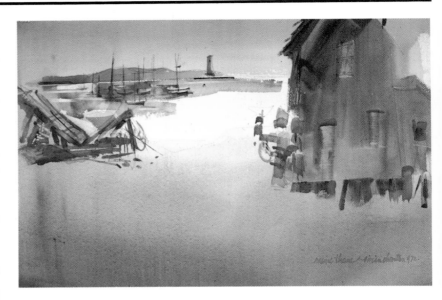

Rocks and Surf, *by Edgar Whitney.* This is an excellent example of wet-into-wet techniques used with remarkable control in a very spontaneous way. The painting emphasizes the tremendous contrast between the light, soft, fused ocean spray and the sharp, hard, angular rocks. The artist has used wet-into-wet techniques over the entire surface, yet no part of the painting appears labored, and the impression of the sea is strongly felt. Notice how he reserved the beautiful white of the paper for the ocean spray, with wet blending of light bluish tones in shadowed areas, and how he set up three distinctive tonal values between the three major elements—the foam (light value), sky (medium value), and sea (dark value). The rocks contrast not only in texture, but also in color. The warm colors of the rocks make them advance, while the cool colors of the foam, sea, and sky force them to recede.

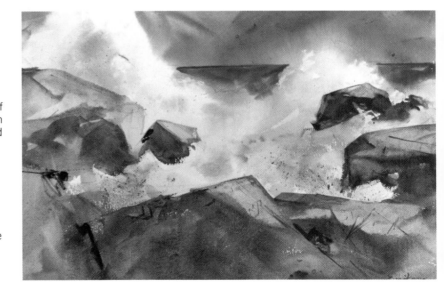

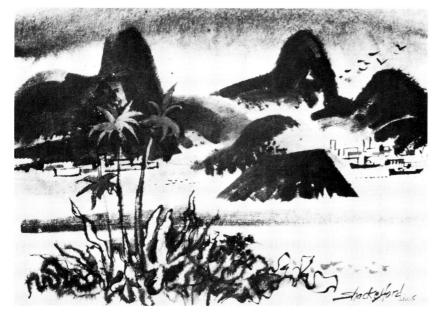

Rio Hills, *by Bud Shackelford*. This painting was done during a painting workshop in Rio de Janeiro. It's a juicy wet-into-wet watercolor, with rich glows and glazes enhanced by the neutral gray washes that surround them. The fusing of color was accomplished by saturating both sides of a half sheet of cold-press watercolor paper in water and lightly wiping off the surface with a paper towel. The first washes in the sky and sea were applied with a large, flat brush in long horizontal strokes of neutral colors. The paper remained wet long enough for continued fusing of all the hill shapes in rich colors and dabs of texture. Rewetting the left foreground, I drew the vegetation with a straight, pointed pen and India ink. It fused and crawled in interesting ways. Finally, as the paper dried, I completed the ship, shoreline, and birds with rapid brushstrokes.

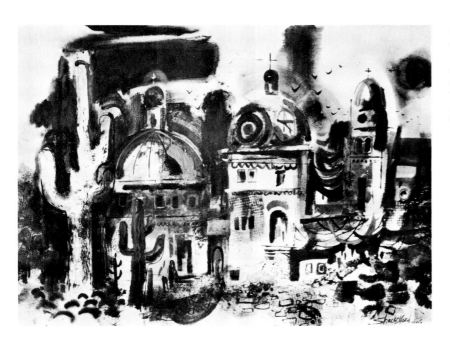

Majestic Mission, *by Bud Shackelford*. For a change of pace, I gave myself a little over half an hour to create this full-sheet mission subject with quick wet-into-wet color happenings (sometimes called "happy accidents"). I had a small sketch for reference, but the paintings really developed as I worked. First, cold-press paper was thoroughly moistened on both sides with a sponge to take full advantage of the wet-into-wet technique. Then I started by applying diluted combinations of colors vertically and horizontally, including a strong phthalo blue sky effect. While the paper was still moist, the heavy, moody cloud accent was fused in over the sky. Then, dipping opposite edges of a flat brush into warm yellows and siennas or umbers, I quickly swooshed in the domes in various shapes and sizes. A combination of stampings and brushwork finished the painting.

CHAPTER TWO
TEXTURES

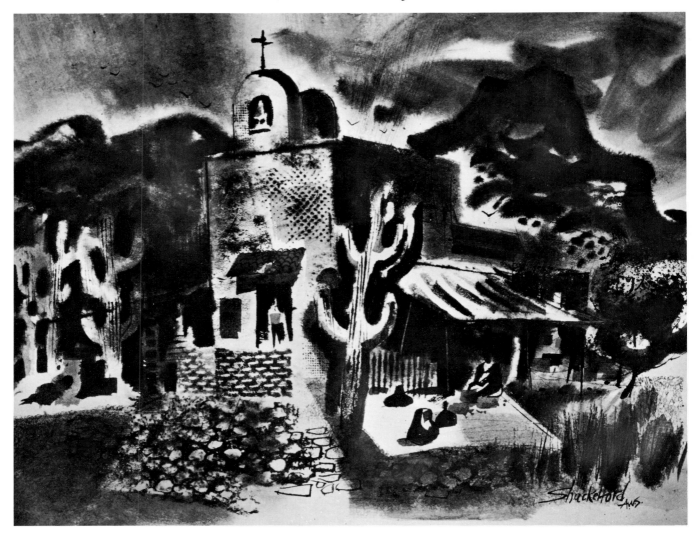

Mission Bell, *by Bud Shackelford.* This painting is loaded with experimental surface textures, mostly transferred from materials such as corrugated papers, raised surface packing papers, burlap, sponges, and other materials described later in this chapter. The front wall of the mission has textures stamped from pebbled mat board, dot-patterned packing paper, and burlap. The brick wall is stamped with a Nylonge sponge which has this surface texture; and the foreground cobblestone effect is created with a Swiss-cheeselike sponge with holes in it. Mat board

edge stampings appear in the cactus plants and edges of the building, and a corrugated paper stamping appears to the right of the central cactus. A natural sponge stamping creates the foliage on the tree at the right and a kitchen sponge is used in its rectangular shape to stamp the back of the mission. Finally, a fine-pointed brush is used to suggest tile canopy textures over the doorway, additional cobblestones, foliage in the hills, grass textures, tree trunks and branches, and additional tree foliage.

Textures are the surface qualities that make a concrete wall look like concrete, a grass area look like grass, a brick wall look like brick, and so forth. Creating textures can be one of the most exciting events in watercolor painting. Texture is especially important in contemporary art, along with strong pattern and design.

Textural effects are created when small repeated shapes are grouped together. For example, a group of white-headed cattle in a distant field can be suggested by many repeated dark dashes with white spots; and crowds of people at a ball game can become a texture of tiny lights and darks. Textures can be realistically or symbolically designed, and each painter will eventually develop his own method of suggesting them.

Textures can be created many different ways with a brush: by using drybrush and split-hair techniques with very little water on the brush; by flicking pigment off the brush; or by painting small dabs of pigment in ways that suggest textures. Brushlines also can represent the grain in wood or cracks in rocks; washes with reflections painted into them can suggest shiny metal and glass.

In this chapter we'll experiment with other ways to create texture by produce "impressions" of textures. These texture effects are the results of applying pigment to a textured material and stamping the impression onto the watercolor sheet.

This experiment in more creative painting is a method for redesigning nature. It ties in with the more spontaneous "surprise approach" to painting and can produce textural gems if everything goes right.

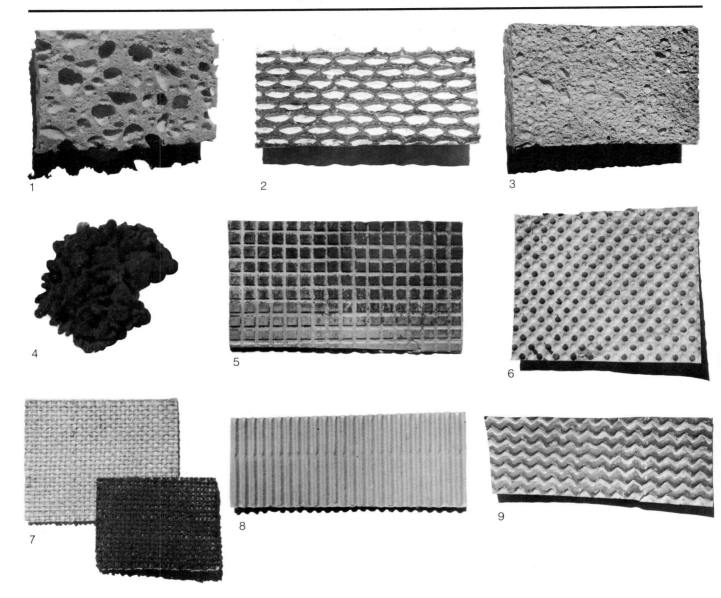

Textures can be created with a variety of stamping materials. Although you may wish to experiment with other textured materials, the materials I use here, pictured above, are: (1) A large cellulose sponge with Swiss-cheeselike holes, which is great for pebble, rock, and cobblestone effects; (2) the Nylonge-brand super surface sponge, made by the Nylonge Corporation, Cleveland, Ohio 44102 (this is a cellulose sponge that has a textured pattern that resembles bricks); (3) a commonly used kitchen-type cellulose sponge that has a fine surface texture that suggests sand or mortar (it's sold in department stores, supermarkets, drugstores, and auto supply houses); (4) a natural sponge, which is excellent for creating tree foliage, rough earth, concrete walls, and the like and can be purchased in art supply stores; (5) a paper plate with square dot patterns (used for serving pizza), ideal for creating concrete block wall effects; (6) numerous "packing papers" with mechanically textured surfaces and ridges that strengthen the papers; (7) burlap wallpaper (burlap cloth backed with paper) stampings which suggest such things as textures and nets;

(8) corrugated paper used for packing (also around light bulbs, packaged Listerine bottles, and so forth), ideal for corrugated roofs and railings; (9) "rippled" pulp packing is useful for symbolic water ripples. Each manufacturer of pulp packing papers has his own pattern or design. You can find these products in department stores that sell china, glassware, or other breakable products and in shopping center trash cans, where interesting textured materials often turn up. Shown here is a pulp packing paper with raised, mechanically spaced dots. It can be used for a textured tone area, screens, masses of bolts, nails, and similar textural effects.

In addition to stamping materials, you'll also need flat sable brushes, sizes 1″ and ¾″ (25 and 19 mm), for applying watercolor pigment to the textured stamping materials. (Aquarelle brushes are excellent for this.) You'll also need fresh, moist pigment on your palette. Since stamping transfers are created by applying watercolor pigment to the textured material and pressing the pattern onto the painting, soft pigment is required for it to print properly.

APPLICATIONS

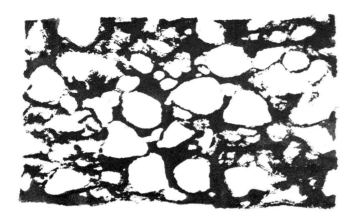

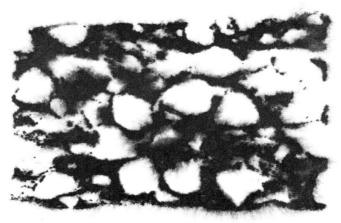

Swiss-Cheese Sponge Stampings. These practice stampings were applied with a sponge having Swiss-cheeselike holes. To make the left stamping, which is on dry paper, apply rich pigment over the slightly moistened sponge with a flat brush and immediately place the sponge face down on the paper. Press lightly, and tap all over. Being careful not to let it slip out of position, raise one side to check the impression. If necessary, tap several more times until the desired image is achieved. For the stamping on the right, which has a fused soft edge, dampen the paper where the stamping is to be made. This time, apply drier pigment to the sponge, and repeat the process. Practice will soon show how wet the sponge, pigment, or paper should be for the desired fused result.

Creating Rock Textures. The Swiss-cheese sponge is excellent for rock textures. This example illustrates a rocky area with hard-edged and fused sponge stampings. To paint it, moisten the paper everywhere except for the lower left portion. Wash in the background tones with a flat brush; then draw the large rocks with a pointed sable brush to set up the subject. Now load the surface of the sponge with rich pigment, and stamp it into the lower left. Then apply more pigment on the sponge, a little drier this time, and stamp it into the still moist background area. Add a few blades of grass to complete this little rock study.

This type sponge can also be used to create the textures of stone walls, buildings, cobblestone streets, walks, and similar stone effects.

Nylonge Cellulose Sponge Stampings. This bricklike set of stampings is accomplished with a Nylonge-brand cellulose sponge. As in the preceding example, the stamping on the left was made on dry paper and on a moistened portion of the paper. The procedure is also the same. After applying the stamping on a dry surface, I found it helpful to "touch up" several parts that left holes or incomplete impressions. I used a pointed (round) sable brush and the same pigment. The "fused" stamping on the right was done on the damp surface. If your paper isn't damp enough, spray a little moisture over the paper with a fine spray atomizer, using clean water, and fusion will continue.

Creating Brick-Wall Textures. The Nylonge sponge is used here for a brick wall that is in turn joined to a wooden door and wire fence. Each item suggests a different texture. To paint them, first moisten the background portion of the paper and brush in the sky and hills. Since the paper must now be dried, you might wish to use a hair dryer to shorten the time. Now brush in the crisp lines of the mission building. To paint the brick wall, moisten the left side of the paper, keeping the right side dry, and work rich, medium-dry pigment well into the surface of the Nylonge sponge. Stamp it once for the whole brick wall. You can suggest the wooden door with a flat wash and add lines of the door, wire fence, and small trees with a no. 8 round sable brush. Finally, add a light wash over the left side of the brick wall and in the foreground.

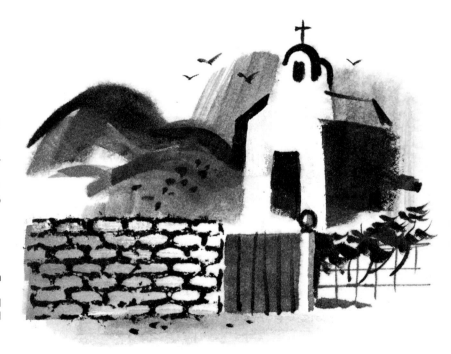

Ordinary Kitchen Sponge. An ordinary kitchen cellulose sponge creates the fine texture shown here. Again, the hard-edged stamping on dry paper is shown at the left and on wet paper at the right. To create these effects, follow the procedures used for the Nylonge sponge in the previous example. Be sure to use wetter pigment on the sponge when stamping on a dry area and drier pigment when stamping on a moist or wet area. Too-wet pigment will fuse out all detail on a wet surface, and too-dry pigment will skip when printing on dry paper.

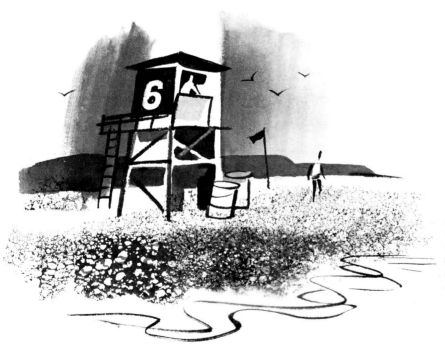

Creating Textures of Pebbles and Sand. The fine textures of a kitchen sponge are ideal for small pebbles and sand, as illustrated here. As in the previous example, wash in the sky and background first; then paint the lifeguard station. Now moisten the center foreground area only. First, for the pebbled effect, apply a hard-edged stamping to the front left side and then a fused stamping to the center portion. Finer-grained sand texture is accomplished by applying quite dry pigment to the semimoist sponge and lightly tapping it over the surface, shifting the sponge each time before tapping. The kitchen sponge is also great for creating masonry walls, earth, and asphalt roads or for adding a textured tone to any area.

Natural Sponge Stampings. The natural sponge is a "natural" for foliage stampings and useful for many other spotted textures, too. The stamping on the left is dry, and the stamping on the right is wet. To create the dry texture, moisten the sponge and squeeze out most of the moisture. Then apply rich, fairly wet pigment to the textured portion of the sponge. (Sometimes squeezing the sponge with your fingers spreads the fibers for a better texture.) Immediately apply the texture by tapping the sponge several times over the dry surface. A strong press will produce a heavy texture, and light taps a fine texture. Next, try the same methods on a wet or moist surface. Use both wet and drier pigment, as more fusion can be desirable in some foliage areas.

Creating Foliage. Various natural sponge stampings in dry and wet areas are applied to the trees here. The darker tree on the left was made by tapping or pressing a sponge with lots of dark pigment many times over the same area. The limbs can be scraped out with a knife or tapered brush handle before the pigment is dry, though here I painted it in with opaque white. Other trunks and limbs here were quickly sketched in with darker pigment and a fine-pointed sable brush (the no. 8 round).

The natural sponge is also ideal for the uneven textures of shrubs, rough concrete walls, rough earth and foreground areas, large rocks and boulders, distant growth on hills and mountains, plus rugs, carpets, and floral textures.

Pressed Pulp Paper. These square-dot textures were created from a cut-out section of a pizza pie plate made of pressed pulp paper. The texture has rather limited uses for realistic painting, but it's exciting for more creative works. Again, it's stamped in both dry and wet areas. Pulp papers absorb less pigment than sponges, and one simple coating of pigment is sufficient. A flat brush dragged over the surface at an angle will apply pigment only to the raised surface. It's okay if pigment gets in the ridges, as long as it doesn't "print" on the paper. Press the material onto the paper and hold it in position with two fingers. Lift one edge at a time to check the transfer. Keep pressing if a darker impression is desired. With practice, you can even add additional pigment to the lifted surface and restamp.

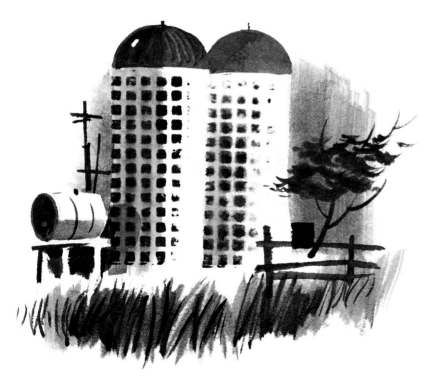

Creating Stone or Concrete Blocks. The example contains two large silos, with a few simple props and brush textures to enhance the subject. All washed tones are applied first and allowed to dry. You can either cut your stamping material to the desired size and proportion or apply pigment to an area of the stamping material equal to the area to be printed. Apply less pigment where the silo appears to turn to the left-hand side of the silo and allow it to dry. This is a dry-surface stamping. Now rewet the right silo and tone it slightly. Immediately stamp the square-dot pattern onto the moist area so that the texture will fuse slightly. (Soft-edged and hard-edged variations complement each other.) Square-dot textures are also useful for multiple-pane windows, skyscraper windows, patio surfaces, and abstract patterns.

Dot-Pattern Packing Paper. These two sets of textures are created by using pulp packing paper embossed with round dots. Try to apply the pigment just to the raised dots, dragging a flat brush with pigment at a rather low angle over the surface. With this pattern, you must be careful not to get much pigment in the valleys between the dots. Apply the stampings exactly as with the square-dot packing paper. (I also found a pair of tennis shoes with a slightly larger round-dot pattern on the rubber soles that was perfect for stampings, so keep your eyes open for good stamping materials other than those suggested here.)

Creating Multiple-Dot Textures. The boxcar example shows both decorative use for a mechanical texture and a realistic use. Applied as a hard-edged stamping on the side of the boxcar, it serves as a design relief from the other surface textures on the front, top, and rear of the car. Again, apply the pigment only to stamping material that is the exact size and shape that you need in the painting. The dot texture is also used as a more realistic suggestion of cinders under the tracks by applying numerous off-register stampings on a moistened surface. Here the dot material is slightly shifted each time it is raised and tapped, and pigment is applied lightly to the moist area. Mechanically spaced dots can also suggest bolts in bridges and steel structures and patterns in clothing and can create exciting abstract textures.

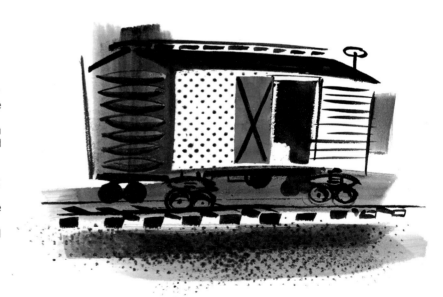

Burlap Wallpaper. Burlap stampings produce great woven effects. The best material for this texture is a burlap wallpaper, which is burlap adhered to a paper backing. The backing prevents the material from shifting at angles when you work with it. To make a stamping like the one on the left, work the pigment into the burlap until the material is slightly moist and try the stamping in a dry area. Since the fabric is flexible and spongy, some practice will be needed before you can get an even texture. Hold the fabric in place, and continue checking with the corner-lifting method previously described. Now dry the burlap slightly with a tissue and apply drier pigment to it for the stamping on the right, which is done on moist paper. Use a light touch to avoid smudging. However, don't worry if it doesn't print evenly. Slight tonal variations can be very interesting.

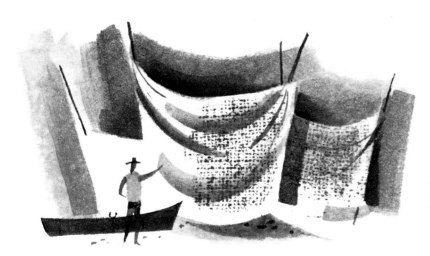

Creating Nets, Sails, and Tents. These three nets would be dull and unconvincing without the stamped cloth textures. The closest net has the crispest detail, a burlap stamping on a dry surface. The recessed net on the right-hand side has a softer fused appearance, created by stamping the burlap in a moist area. The subject is enhanced with the addition of a boat and fisherman. Burlap stamping can suggest canvas for sailboats and tents, and the textures of clothing. It can also be used for shingle roofs in the distance or screens for porches, doors, and windows.

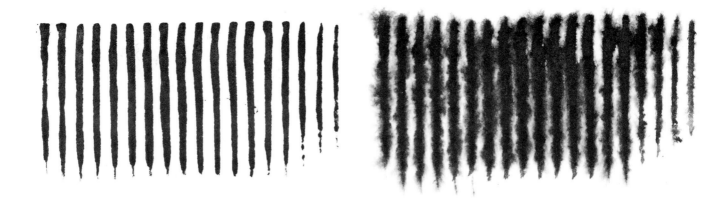

Corrugated Paper. The textures shown above are made with corrugated paper materials. Since they're less absorbent than pulp packing papers, use less water in your pigment. Drag the rich pigment across the raised ridges of the paper, and press onto the dry paper for a hard-edged impression like the stamping on the left. Easing up on the pressure creates a thinner taper-off at the right.

For the soft-edged stamping on the right, I wet the paper and apply a fused version, as previously described. I caused additional blending by spraying the paper lightly with clear water from a fine-spray atomizer. (Mask other areas with a hand-held sheet of paper when spraying.)

Creating Roofs, Fences, and Pilings.
Corrugated roofs, fences, and pilings are all naturals for corrugated stampings. This wharf scene illustrates a corrugated stamping for a roof and the wharf underpinning. Trim the stamping material to the proper size and proportion ahead of time, and moisten the right-hand side of the roof. Then brush rich pigment across the corrugated ridges and stamp the impression once over the entire roof area. Where the paper was moistened, fusion takes place; where the paper was dry, on the left side of the roof, the print remains crisp and sharp. The variation creates interest. Now tone the area of the pilings, and stamp this area as you did the first.

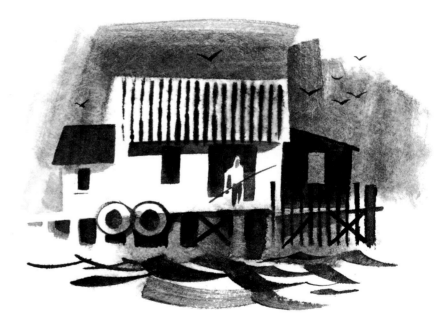

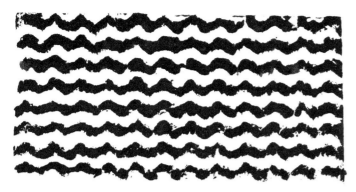

Rippled Packing Paper. Pulp packing paper creates a mechanical ripple pattern that suggests water. I've also seen tennis shoe soles and rubber floor mats with similar patterns. As in previous transfers, pigment is applied to the texture material and stamped in both dry and wet areas.

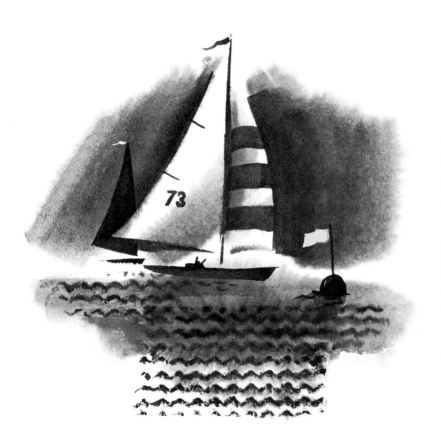

Creating Rippled Water. The sailboat exercise is created by moistening the entire sheet and washing in the sky and water tones, leaving the white sails. Add a curved wash tone to fill the sails with wind. Blot the lower central portion where the crisp portion of the stamping appears with a blotter of paper towel. Drag rich pigment across the rippled paper, with a flat brush as before; then while the water tone area is still moist, stamp the ripple pattern over the moist tone and into the dry area below. Continue extensions of stampings on both sides of the toned areas without applying fresh pigment for a softer effect. To finish the sailboats and pylon, darken the sky up to the edge of the sails and complete the few remaining details. Ripple stampings can also suggest plowed fields, staggered fences (using two or three ripples with spaced posts), siding on houses or barns, and similar objects.

TIPS

1. Squeeze out plenty of pigment for your stamping material. You'll use more than you expect.

2. Add plenty of pigment, especially to the sponges, so that the color will transfer without too much pressure. Excessive pressure thickens or smudges the texture.

3. When your watercolor paper is dry, you may need to add wetter pigment to the stamping material.

4. Test the stamping on a spare sheet of paper before you apply it to a critical area of your painting.

5. If the stamped texture skips in places, you can carefully retouch it with a fine brush.

6. For another look, try stamping opaque color over darker areas that have dried. (For opaque effects, use the cadmiums, ochres, cerulean blue, or colors mixed with white.)

7. Before you lift the material, be sure to check your stamping by holding one side and lifting the opposite edge to view the result.

8. Be constantly on the lookout for textured stamping materials. Look for small pieces of material for smaller paintings or to vary the effect. Ask friends to save textured materials, too!

9. Try placing several colors at once on the stamping material in separate areas or loosely blended.

10. Don't crowd busy textures together. Leave space passages, tonal separations, and other visual areas of rest nearby. Flat surfaces complement textures.

11. If the holes in your Swiss-cheese sponge look too large for a particular area, try stamping it again so that it's slightly off register and narrows the holes.

12. To pull a textured area together and tone down vibrations there, glaze a diluted tone or color over it after it's dry.

PROJECTS

1. Practice stamping with all the textured materials you've been able to collect. It is important to learn to control your materials before you apply them to paintings. First, using burnt umber, try separate stampings on dry, slightly damp, and wet areas of your watercolor sheet. It takes a little practice to learn how much pigment to apply to your material. Also, try shifting the position of your stamping material and stamp over the original stamping for multiple textures.

Next try varied colors. Applying sequences of colors on the same stamping material before pressing onto the watercolor surface is also effective. Note the varied color textures in some of the reproductions of paintings shown in this chapter.

2. Develop a landscape using at least four different stamping transfers for texture. Lay in your pencil drawing from a good composition plan first. Then as you develop the preliminary painting, set up the textures most suitable for the desired effects. For example, corrugated paper for roofs and fences, Swiss-cheese sponge for cobblestones or rocks, Nylonge sponge for brick areas, and a kitchen sponge for plaster or adobe walls. In other words, plan your subject first, and then use textures to enhance the surface qualities.

3. Develop a seascape painting using a selection of at least four stamping transfers to set up textures. Include a wharf and boats. Lay in your pencil composition first, then develop the preliminary painting using stamping materials suitable for seascape textures, such as ripple patterns for water, Swiss-cheese sponge for rocks, kitchen sponge for sand, or burlap for nets or sails. You may find that many of the same stamping materials used for the landscape project can also be used in your seascape.

4. To spur your creative abilities, begin without any subject in mind. Just wet the paper and start applying arbitrary washes of color and tone. Try to develop good tonal contrasts, leaving plenty of light passages. Apply an assortment of stampings here and there. When you have an interesting abstract underpainting, turn the paper on its side or upside down. Do you see a subject possibility? If not, add a few more washes, some arbitrary shapes and forms, and maybe additional textures. Explore the fun of just letting it happen. When rich pigment is applied to wet paper and when arbitrary shapes and textures are added, some of the most exciting paintings can be developed. But don't be discouraged. It may take several tries.

DEMONSTRATION

Step 1. This painting was inspired by an old photograph of a distant lighthouse with a large foreground of driftwood that offered the opportunity to paint a variety of textures: smooth driftwood next to rugged rocks, metal railings, plaster walls and tile roofs, grass and rippled sea. I develop the composition with a number of thumbnail-size felt-pen sketches, redesigning the driftwood to lead the eye to the lighthouse. I add boats and nets for interest and texture, suggest two sails to give more importance to the sea area, and include a small figure for a touch of life. Then I begin the watercolor.

I select a full sheet of 70-lb Strathmore Aquarius II watercolor paper. Since it lies perfectly flat and won't buckle when wet, it doesn't have to be prestretched. Also, the surface is smooth enough to take excellent textured stamping transfers. I lay in the composition with an HB pencil. This pencil holds a good edge, is not too dark, and won't disappear or smudge when the paper is wet. At this point, even before I start to paint, I have a pretty good idea where the various stamped textures will be placed.

Step 2. I wet the paper thoroughly on both sides with a saturated sponge. Then, with a 1½″ (4 cm) flat brush, I apply light, transparent washes of phthalo blue mixed with a touch of viridian green in vertical strokes to the sky, staying clear of the lighthouse and boats. Vertical strokes appear more lively than horizontals. I add more viridian to the middle-distance areas and use a stronger mixture of phthalo blue and viridian green to define the lead-in movement of the driftwood logs.

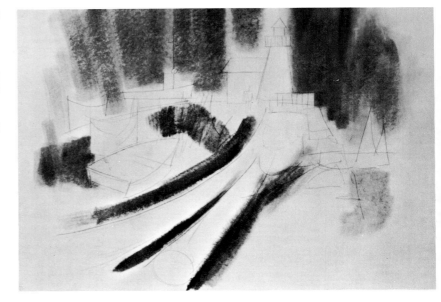

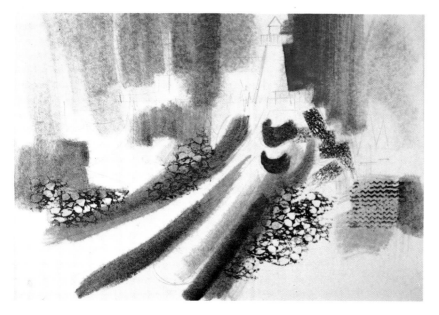

Step 3. Now the fun begins. Exciting things happen when rich pigment is charged into wet paper. With a 1″ (25 mm) flat sable brush, I vigorously apply strong color strokes vertically, horizontally, diagonally, and in massive curves to capture a strong design feeling right at the start. At times I mash, twist, or turn the brush, as in the negative areas at the far end of the logs. The important light areas are carefully reserved. Up to this point, I've concentrated on negative passages, using cool colors (phthalo blue and viridian green), which tend to recede.

I now apply three burnt umber textures in this early state: a Swiss-cheese sponge stamping to create rocks in the spaces on both sides of the driftwood; a few kitchen-sponge granular stampings for the large rock foundation supporting the lighthouse; and a dark ultramarine blue stamping with ripple packing paper to suggest the sea in a symbolic way. I add a neutral green tone of viridian with a touch of raw umber to the right of the ripples for balance; brush drier ultramarine blue with a touch of raw umber over the sky area and to the edge of the lighthouse to define its shape; then add to the left side a few vertical strokes of the same color, slightly thinned with water.

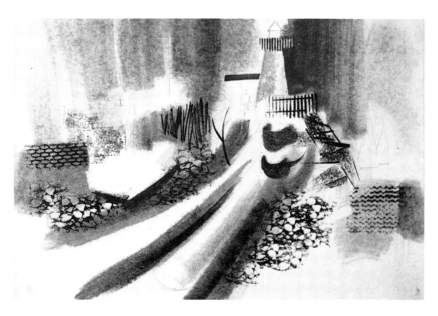

Step 4. A warm gray (burnt umber mixed with ultramarine blue) is stamped over a toned area with the Nylonge sponge for a brick wall; burlap stampings of raw umber and yellow ochre are used for the net textures; corrugated paper stampings become railings and iron fences; and fine-line brushstrokes of warm gray make tall grass textures. I cut corrugated paper to the size of the iron fence and apply cadmium yellow, cadmium red, ultramarine blue, and burnt umber across the ridges with a flat brush, then stamp it into the area. (Remember, everything is reversed in a stamping.) Since textured areas set up busy tensions, I offset them with quiet restful ones. I also separate textured areas with open passages, tonal areas, or flat untextured shapes. Where textures like the dark brick wall and the light-textured nets meet, I contrast them in value. I also sharpen edges and create shapes and forms. The underside of the rowboat is boldly strengthened with a dark cool gray shadow of burnt umber and ultramarine blue worked up to a crisp contour edge. Then I apply a dark shadow (ultramarine blue and alizarin crimson) to the roof, and add a flat mortar texture (new gamboge and raw umber) to one side of the lighthouse tower with a pebbled mat-board stamping. An edge stamping forms the left side of the tower (see next chapter).

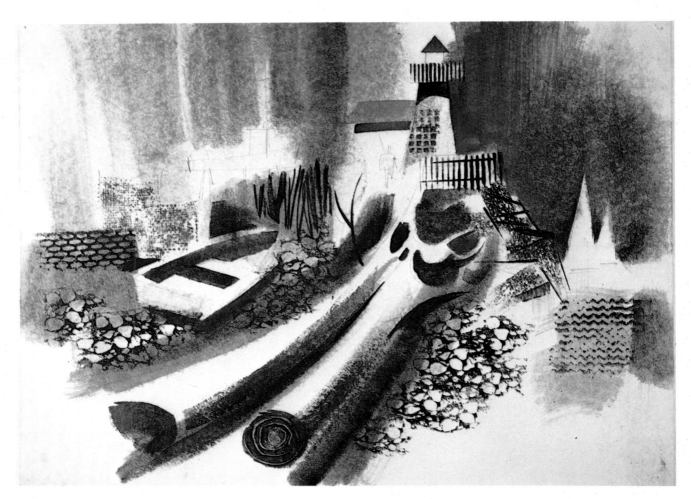

Step 5. I paint the darker sky tone of ultramarine and a touch of raw umber around the two sails and add a cadmium orange roof to the building. I top the lighthouse with a rich, alizarin crimson roof and suggest the interior of the rowboat with a crisp, cool shadow on the inner side and under the seat. Then I suggest a few textures. With square-block packing paper painted a warm gray, I stamp the dry toned area of the tower to suggest a block structure. I create a cylindrical form by painting the circular ends of the logs and scraping the moist pigment out with a tapered brush handle for the "age-ring" texture. Then I concentrate on pulling the painting together.

I also note the negative passages and positive forms already finished and plan the colors of the unfinished parts. The positive shapes and forms are the most obvious: the nets, lighthouse, roofs, railings, fence, rocks, and brick wall. I suggest their solidity with warm colors, including warm grays, because they make objects appear to advance. The negatives are the spaces between the branches and twigs at the end of the logs, the interior of the rowboat, the sky, the space passage between the rowboat and the log, and the water. I paint them with cool colors so that they will appear to recede.

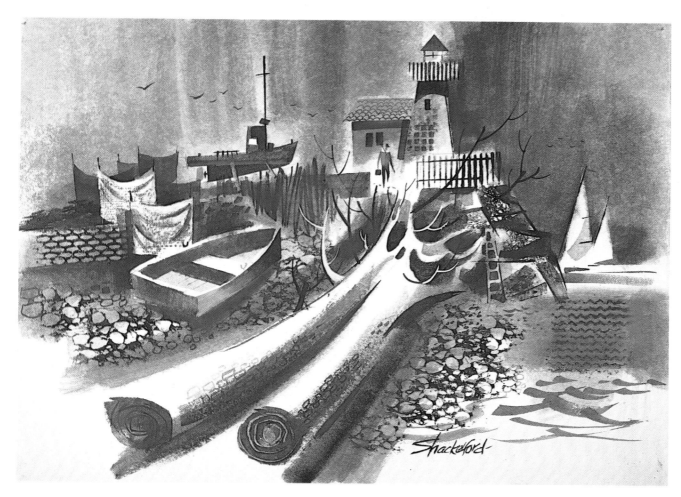

Driftwood Lighthouse. During the finishing steps of this painting, I make the positive shapes more obvious by adding warmer colors to the boats, roofs, and tiny figure. There the most intense color, Winsor red, is used to create a focal point. The figure is also set off against a light spatial area. I use other contrasts, too. Regarding value, note how the addition of dark nets sets off the original, lighter textured nets. Regarding shapes, the flat, silhouetted shapes of the dark nets and distant boat contrast with the many textured areas. Regarding colors, a yellow light appears in the lighthouse.

The darker tone to the right of the ripple texture in the sea has bothered me since Step 3. I finally correct it now by lightening it with a damp-sponge lift-off (described in a later chapter). Then I wash the overall neutral greenish tone of viridian and phthalo blue plus a touch of raw umber over the entire sea surface and apply a rippled texture to fuse it all together.

With a fine no. 8 pointed sable brush, I paint the tiles in the lighthouse roof, a ladder, windows, and the bark of the driftwood logs. Final details also include twigs and branches, sailboat hull, battens and flag, a flight of birds, and the foreground water. Again, you must have a brush with good snapback that also retains a sharp, fine point for these crisp spontaneous brushstrokes.

OTHER EXAMPLES

Rock Harbor, *by Bud Shackelford.* Instead of interpreting the scene realistically, this painting emphasizes design elements, combining two-dimensional flat shapes with three-dimensional forms. The painting is alive with subtle distortions of shapes and forms. Some buildings are side views and others three-quarter views. One boat floats in the water and another is an upright two-dimensional pattern. The painting is also loaded with angles, curves, and textures. The color scheme is analogous, with warm colors dominating. Numerous stamped textures build rich surface qualities. Most of these textures are symbolic or contemporary. For instance, the "ripple" texture stamping between the two boats symbolizes water, the corrugated paper stamping on one of the shed roofs and the burlap cloth stamping over the draped net symbolize corrugated metal and woven fabric, and the edge stampings from corrugated box strips are symbolic of cross-sections of deck planking.

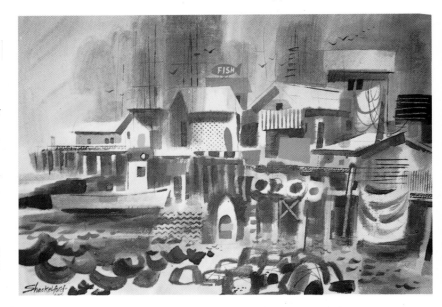

Fishing Village, *by Bud Shackelford.* This demonstration was created on a Painting Holidays workshop in Tahiti and incorporates many of the same stamping textures used in *Mission Bell.* The sky, hills, and vegetation were painted first with a series of multicolor washes. When the paper was dry, the texturing was begun. Black India ink was applied with pipe cleaners and pens to form interesting fused-leaf tree branches and a few texture spots. Paraffin resist (see Chapter 7) was used on the oval leaves to the right. Finally, the entire base of the painting was textured with a series of stamping transfers. Can you pick them out?

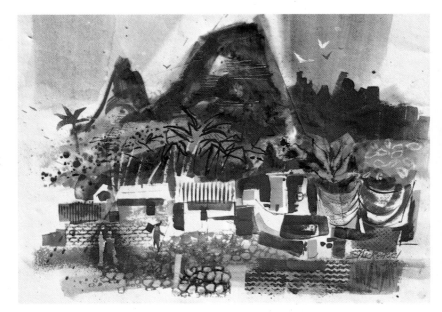

Pavilion and Bay, *by Rex Brandt.* This is an example of a flattened painting designed into vertical and horizontal space divisions. Brandt has created numerous textures with brush and sponges. The shingle effect on the face of the tower is a ripple pattern applied with a pointed brush, as are most of the linear details and textures. A natural sponge was used to form some of the textures in the tree foliage. Edge stampings were used for the longer straight lines (see Chapter 4). Notice his expert use of cool colors to set up receding negative passages and warm colors to bring positive shapes forward.

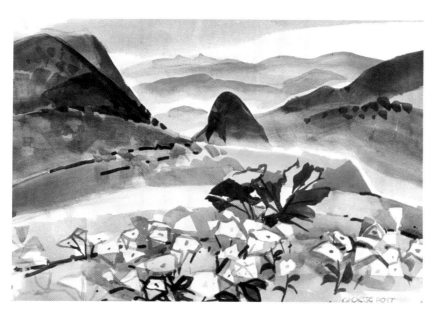

High Country, *by George Post.* This painting is a fine example of Post's ability to form spontaneous patterns and textures with brushes only. In the foreground, numerous repeated shapes of white blossoms create the texture of wild flowers. Additional jabs with a brush suggest the texture of shrubs on the hills.

CHAPTER THREE

EDGE AND FLAT STAMPINGS

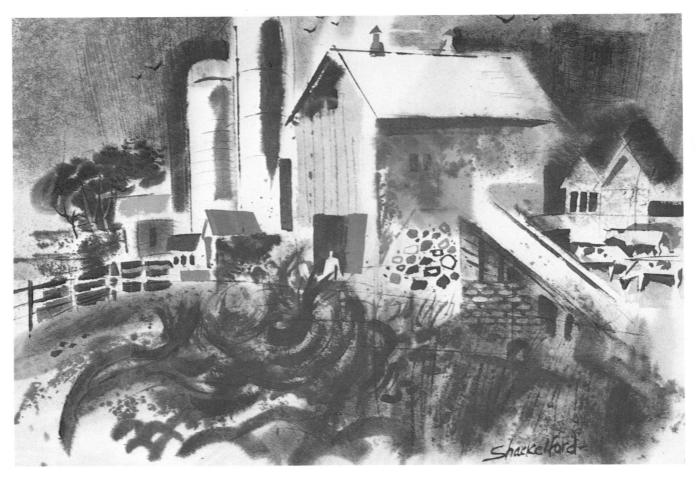

Tall Barn, *by Bud Shackelford.* This painting is a good example of a painting where edge and flat mat-board stampings have been used to define shapes and forms and to create exciting surface happenings. The larger orange side of the barn is a massive texture created by applying several colors (burnt umber, burnt sienna, and cadmium orange) to the flat surface of a precut piece of pebbled mat board and pressing it into the slightly moist paper. Edge stampings, some multicolored or stamped off register to set up tensions and activity, are used to define shapes and forms. The edges of mat board are used to transfer color to the painting through procedures explained in this chapter. The edges and angles set up by these stampings are offset by the soft rolling curves in the foreground grass. Notice the brick effect under the ramp, which was stamped with a Nylonge sponge. When dry, the whole triangular area was glazed with diluted gray-blue pigment. A dragged edge stamping completes the far side of the ramp. The stone texture to the left was done with a fine-pointed brush. This is a triadic color scheme with blues, yellows, and reds dominating.

You may be surprised to learn that a piece of pebbled mat board left over from cut mats can be one of your most effective texture tools. By coating the flat side of the pebbled surface of the mat board with paint and pressing it onto your watercolor sheet, you can produce remarkable texture for such objects as hills, concrete and mortar, tree foliage, and rocks.

Strips of mat board turned on their edge are also tools for edge stampings. With them you can make beautiful crisp lines (even ones varying in color); graceful curved or dragged lines for positive shapes like posts, pilings, and windmill blades; and crisp shadows or edges. The same dragged edge stampings (using cooler colors so the areas recede) can create negative passages such as spaces between pilings, openings in doorways and under canopies, and spaces between objects. You will also discover that ordinary corrugated boxes, when sliced in strips, expose an interesting cross-sectional pattern that can be useful for additional types of edge stampings.

Basically, this is a printing process. You're applying pigment (instead of ink) to a master plate (mat board) and pressing it onto a sheet of paper (watercolor paper). You can actually print letters and numbers by painting them in reverse on the mat board and pressing it into position on your painting. The exercises in this chapter show a number of ideas for applying textures, textured shapes, and lines to paper by using transfer methods with simple pieces of leftover mat board and cardboard-box strips. The effects are quite different from those you get when painting with a brush.

MATERIALS AND TOOLS

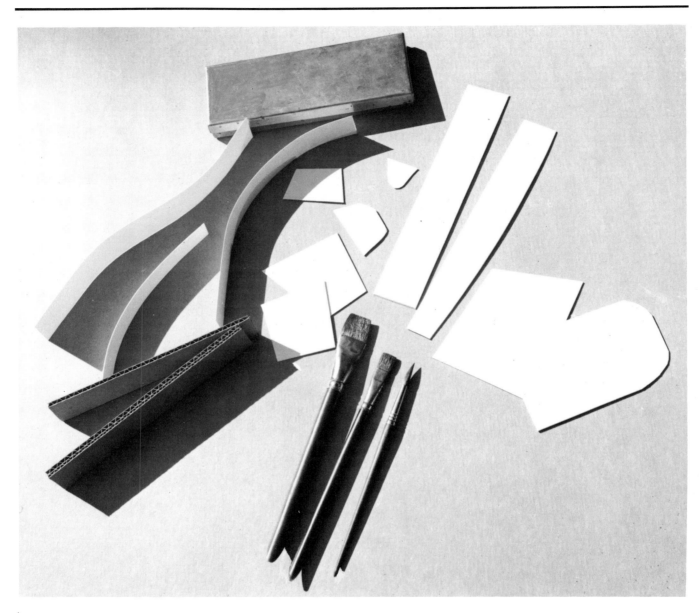

For the exercises and examples in this chapter, you'll need 1″ and ½″ (25 and 13 mm) flat brushes and a no. 8 round sable brush; your watercolor palette, with fresh paint; pebbled mat-board strips precut about 1″ × 8″ (2.5 × 20 cm); flexible strips of 140-lb or 300-lb watercolor paper also cut 1″ × 8″ (2.5 × 20 cm); several flat pieces of pebbled mat board about 4″ × 6″ (10 × 15 cm); strips of cardboard from corrugated boxes about 1″ × 8″ (2.5 × 20 cm), cut so that the corrugated ribs are exposed; and a pair of scissors for cutting specific shapes.

To cut the mat board and corrugated board for edge stampings, use a metal straight edge and a new (sharp) single-edged razor blade (or sharp mat knife). Be sure to hold the razor (or mat knife) straight up and down as you cut across the mat board or corrugated board so that the cut surface, which will be used for the edge stamping, comes out flat and even and will print properly.

You must start with fresh moist pigment, since rich paint is essential for good stampings. I use the 1″ (25 mm) flat brush to apply the pigment to the flat side of the mat board for flat stampings and the ½″ (13 mm) flat brush to apply pigment along the edge of the mat board (or sliced corrugated board) for edge stampings. For all stampings, the pigment must be quickly stamped while it's still moist. If you wait too long, you'll get "skips," or unprinted portions. You may also find it necessary to apply fresh pigment for each stamping, and you'll get different results when stamping into moist areas and dry ones. Remember, only practice will make you proficient.

APPLICATIONS

Mat-Board Edge Stampings. Use a 1″ (25 mm) strip of mat board cut to the length of the line you wish. Moisten the left-hand side of the paper. Apply rich (not too wet) pigment along the edge of the mat board and make several stampings. Tilt the mat board along the edge for finer lines. Next, taking a shorter length of mat board, apply wetter pigment to the edge, and stamp into the dry areas horizontally. Tilt the mat-board edge for finer stampings or use thinner board.

Curved Edge Stampings. You also make gradual curves with the same 1″ (25 mm) mat-board strip. Thinner papers, such as 1″ (25 mm) strips of watercolor papers, are even better and will bend more easily into beautiful curves and S-shapes. Using the same procedure for applying pigment to the edge, bend the board or paper to the curve desired and lower it carefully until it touches the paper surface. Press lightly and lift off. Try it on the moist left-hand side first and then on the dry area. If you want a crisp curved line, don't let it slip.

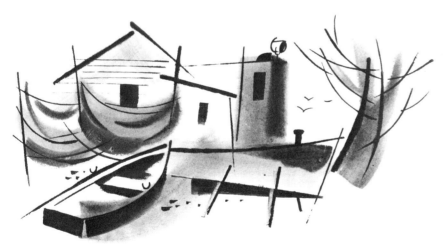

Using Edge Stampings in a Boat Scene. Start by wetting the surface of the paper first and applying a few light and medium washes with the 1″ (25 mm) flat brush. Leave lots of white paper. Add a few darker strokes with the edge of the brush to suggest folds in the nets. Next, apply rich pigment to the edge of a 1″ (25 mm)-wide mat-board strip (paint the edge only as long as you wish the line to be), and begin pressing down edge stampings to form outlines and shapes. (I started in the main roof area with slightly fused lines.) Dry the mat-board or paper edge with tissues before reapplying pigment for a different edge length. Use your mat board for subtle curves and the more flexible paper for tighter or thinner curves, such as those in the tree limbs and twigs and the net. Tilt the mat board for the fine lines suggesting boards on the face of the building.

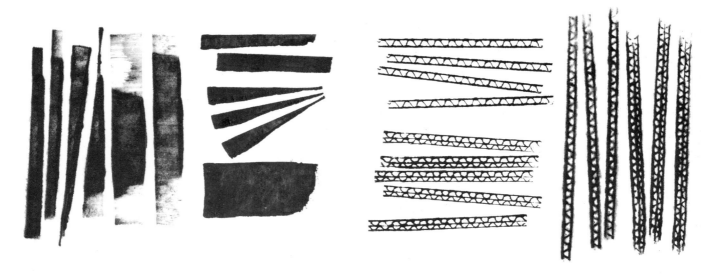

Dragged Edge Stampings. Apply moist rich pigment to the edge of the 1″ (25 mm)-wide mat-board strip, floating a little extra on the upper flat surface next to the edge. Moisten the left side of the paper to see the result in a moist area, and leave the other side dry. Touch the mat board to the paper surface and drag it crossways, with the extra loaded edge in the path of the movement. This will give you a continued flow of pigment. Hold one end of your mat board for a pivot to create the thin-to-thick tapered effects.

Corrugated-Board Edge Stampings. Corrugated boxes come in single and double plies of various thicknesses. For this exercise, cut corrugated board into 1″ (25 mm) strips exposing the corrugated inner cross section. Apply thick, rich pigment to the exposed edge and blow out any filled areas to open them up. Now press the impression onto the paper and rock the edge of the board slightly back and forth, without shifting its position, to make sure every part has printed. Try the fused effect on the left on wet paper, and the dry effect on the right, using both single- and double-ply corrugated board.

Using Edge Stampings in a Wharf Scene. First, moisten the entire surface of the paper and sweep a few light washes from left to right. Leave some whites. Let a darker wash suggest the shadow side of the building. Now press a single-ply corrugated edge stamping onto the damp paper at the cross section of the upper wharf; it will fuse slightly. Use mat-board edge stampings in wet and drier areas to quickly create some of the main shapes and forms. A few flat mat-board stampings cut to size create rock textures on the left, and brushstrokes made with a ½″ (13 mm) flat brush suggest waves. Now place some dragged-edge stampings in the negative passages between the pilings, dragging the pigment from left to right. This will actually create the pilings! You can form the taller dark pilings the same way. On the left, the tapered piling is created using the pivot method. It also creates the underside of the canopy (over the figure) and the tapered dark under the sailboat boom. Finally, drag the edge of the mat board for the dark shadow that appears under the right roof eave, and finish the cross section of the long foreground wharf deck with a long, double-ply corrugated edge stamping.

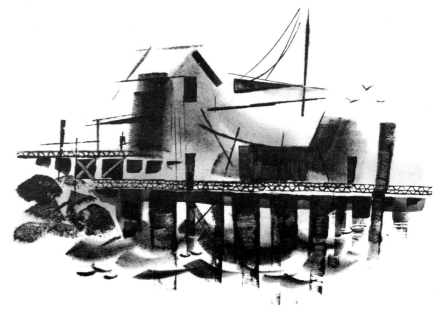

Mat-Board Flat Stampings. Take a 4″ × 6″ (10 × 15 cm) piece of pebbled mat board and cut it into any shape that you wish (these are oval shapes). Apply rich pigment to it with the 1″ (25 mm) flat brush, taking care to place the color within the board and not at the edges to avoid getting hard edges in the finished stamping. Press the upper stamping into the dry area; the result is a crisp pebbled texture. Now wet the lower half of the paper, and press the lower stamping into the moist area. The effect is a soft, fused, pebbled texture. Sometimes I shift the mat board slightly before lifting it for a surprisingly juicy effect.

Cut Mat-Board Flat Stampings. To create some hard-shaped edges with your flat stampings, cut the 4″ × 6″ (10 × 15 cm) mat-board corners into angular or curved shapes with your scissors. Vary each cut for interest. Apply rich pigment to the flat pebbled surface, working it up to the cut edge, and press the impression onto the paper. Try a series of impressions in a dry area (see upper example), rotating the mat board to a different corner for each stamping. Then apply the same process to a dampened area (lower example) for fused shapes and textures.

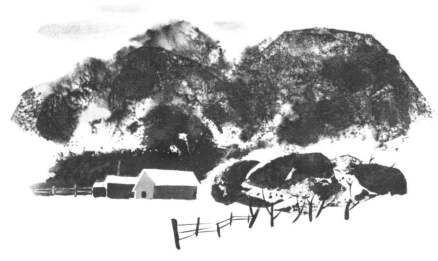

Creating Mountains and Trees with Mat-Board Flat Stampings. First moisten the upper two-thirds of the paper with a kitchen sponge. Brush a few light washes into the hill area and flick a few strokes into the sky. Now cut the edges and corners of a 4″ × 6″ (10 × 15 cm) mat board into curves and angles for the mountain shape. Then brush thick, rich pigment onto the board up to the edges and press it into the moist paper. Where the underlying washes are still wet, some fusion takes place. Now take another 4″ × 6″ (10 × 15 cm) mat board, uncut this time, and brush curved shapes into the center. This time press it into several places in the hill where no edges are wanted. When the right-hand side of the paper is drier, stamp a sharper mountain edge with a shaped mat board. Now remoisten the interior of the hills by tapping the paper with a moist sponge and continue the pebbled mat-board flat stampings. The tree grouping is created with smaller cut pieces of mat board. They are coated with pigment and pressed onto the paper to form the various masses of foliage. Then, with short strokes of a no. 8 sable brush, paint in the tree trunks and limbs and foreground fence. Finally, paint the buildings in flat, simple tones, leaving the snowy foreground an untouched white for a restful contrast to the numerous textures. White roofs are created by painting the dark foliage down to the silhouettes of the roofs.

Small-Cut Mat-Board Stampings. Even small pieces of mat board should be saved for stampings. Cut board into pieces with scissors, paper knife, or razor blades for crisp, angular shapes. Then paint thick, rich pigment over the surface flush to the edges, and press the shape onto the paper. On the left, the wet surface creates interesting veined effects, especially if the mat board is shifted very slightly before you lift it off. On the right, slightly more moist pigment is applied to the pebbled mat board to stamp into a dry area.

Mat-Board Reverse Stampings. Shapes, symbols, letters, and numbers painted with moist, rich pigment can be stamped into your painting with effects quite different from those achieved with brushwork. Remember to paint the image in reverse on your mat board, since the stamped image will be reversed. Try stamping it into a dry area first, as in the upper example above. The result is that the pebbled surface of the mat board breaks up the surface texture. Next stamp it into a moist area (see above right) for softened or fused textures.

Creating a Mission Scene with Precut Mat Stampings and Reverse Stampings. First, moisten the paper slightly in the mission and rock areas and brush in a light wash with the 1″ (25 mm) flat brush, allowing it to fuse. Next, cut out of the mat board a rectangular shape the exact size of the front of the mission, and apply rich pigment to the entire mat surface. Stamp the impression in place. Scrape out the trim around the doorway with the tapered end of the 1″ (25 mm) Aquarelle brush. Now work on the front surface of the bell tower. Cut its shape out of another piece of mat board, rounding the top and cutting out the opening at the bottom. Then paint it and stamp its shape above the first stamping of the mission façade. Now cut the separate rock shapes from small leftovers of mat board. Again, paint and stamp them into position to form the pile of rocks on the left. For the posts, cut thin strips of mat board to shape, and paint and stamp them into position on the painting. The symbolic shape under the shed is painted on a flat piece of mat board and pressed into position, as is the number 3 on the side of the mission. Remember, the number must be painted in reverse. Apply more diluted pigment up to one edge of a piece of pebbled mat board, and press it onto both sides of the pathway to form the open passage. Finally, paint in the dark doorway and finish the smaller details with the no. 8 round sable brush.

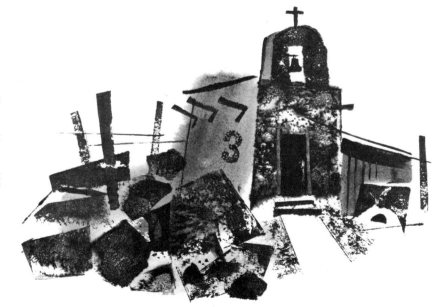

TIPS

1. Use thick but *drier* pigment on your stamping tool when stamping into a wet area. Wet pigment will fuse out and destroy your texture and image.

2. Use *wetter* pigment to stamp into a dry area, to avoid skips in the texture.

3. Until you acquire the necessary experience, practice the stamping on scraps of the same watercolor paper first. Then reapply the paint exactly the way you got your best trial stamping.

4. When your stamping has been pressed into position on the painting, hold one edge of the tool in place and lift the other edge to check your result. If the image isn't complete, lower the tool in place again and press harder in the necessary areas.

5. If you don't let the tool slip, it's possible to lift one edge and reapply pigment to the underside, then restamp it in the same position.

PROJECTS

1. Use burnt umber only or a limited palette of new gamboge, Winsor red, and ultramarine blue (giving you a range of warms to cools). Wet a sheet of watercolor paper on both sides, and apply some light washes vertically and horizontally, leaving lots of whites. If you're using color, use a warm hue of new gamboge and a touch of Winsor red. Next apply a few medium washes, one vertical and two horizontal, avoiding the center. (Use new gamboge with a mixture of ultramarine blue and Winsor red.) Now with edge stampings and dragged edge stampings, create a grouping of barns, sheds, windmills, fences, tree trunks, and branches. (Combine Winsor red and ultramarine blue for a dark color.) Some lines can be totally off register.

 Make use of the diagonal lines for roofs, dragged cool pigment for negative passages (under an open shed or between positive shapes), and warm hues for positive shapes such as posts and fences. Warm colors will be in the range of new gamboges and Winsor reds neutralized with ultramarine blue. Cool colors will be in the ultramarine blue and purple range (combining the ultramarine with a little Winsor red). Neutralize the purple with new gamboge. Don't forget to add some stamped rhythmic curves, and see if you can find a use for a corrugated edge stamping. You'll be surprised how spontaneously you can develop shapes and set up a composition with edge stampings. You can spark up barns and sheds with warm reds and yellows.

2. Practice with raw umber only or with a limited number of colors, such as new gamboge, burnt sienna, and ultramarine blue. In this assignment, you can combine edge stampings with flat stampings. Plan a wharf scene similar to mine, but change everything around. Invent your own building shapes, canopies, sheds, types of boats, and other props. Start with light and medium washes to pull the painting together. Use edge stampings first to set up buildings, boats, and other props. To animate the painting, these shapes can be off register, overlapping, or tilted slightly for subtle distortions. Now cut out smaller shapes of pebbled mat board to set up a pile of rocks with pressed stampings. Cut another mat board shape for a stucco wall or building, and apply a combination of your three colors to the mat board for your stamped impression. Apply flat stampings wherever you feel it's appropriate, and finish the details with brushes.

3. Practice several variations of hills and mountains using flat mat-board stampings in dry and wet areas. Select the colors of your choice. Also add little villages or farm scenes below the hills. (See previous exercises using mat-board flat stampings in this chapter for more information.)

4. Again with the colors of your choice, practice variations of foliage with flat mat stampings in dry and wet areas. Complete the trunks and branches with edge stampings or brushstrokes drawn with a no. 8 round sable. Keep the lines crisp to contrast with the textured foliage.

DEMONSTRATION

Step 1. I often design little sketches with flat vertical and horizontal lines, diagonal lines, curves, or conflicting lines for tensions, that suggest various subjects. Then I make changes (in shapes, positions, props, or sizes) in each sketch until I have several good compositions. In this case I developed several sketches around a theme of wharfs, buildings, hills, and sails. Choosing one as the basis of this painting, I scratch the major design into the dry paper with a sharp pocketknife, pressing hard enough to see the roughened ridges in good lighting. Then I moisten the watercolor sheet on both sides with a kitchen sponge, lifting off excess moisture so there is an even sheen over the surface. With a wash of ultramarine blue and a touch of alizarin crimson, I apply vertical strokes in the sky overlapping into the hills and up to the edges of the sails with a 1½" (4 cm) flat brush. I also add diagonal strokes under the right-hand sails and leading in from the lower right. Then I add a touch of burnt umber to the mixture for a more neutral stroke at the lower left and under the wharf. With a light diluted wash of the same color, I brush over the knife lines to make them appear. Now, with a mixture of ultramarine blue warmed with a touch of alizarin crimson and burnt sienna, I sweep two strokes from the sky into the sails to blend the areas and make the sails appear full.

Step 2. Now for some real fun and surprises! I cut several 4" × 8" (10 × 20 cm) pieces of pebbled mat board with straight sides, slightly curved sides, and rounded corners (each a little different) and start the textured flat stampings for the hills. With my ¾" (19 mm) flat brush, I make separate applications of Winsor red, burnt sienna, and burnt umber over the surface of one piece of mat board, flush to the edges, and press the central hill shape in place. Reapplying these pigments, I make three more smaller impressions: one in the left of the hill and two below left.

Without even cleaning the brush, I dip it into alizarin crimson and ultramarine blue paint and apply variations of these colors on another mat board and stamp the hills to the left with several impressions. With the same colors applied up to the straight edge of a piece of mat board, I stamp the impression flush to the jib sail, keeping the heaviest pressure at the edge. This creates a crisp edge of a cooler color to push back the hills and cause the sail to pull forward, a push-pull technique. The hill on the far right of the sails is also stamped in, and I suggest a few dark hills between the sails with a no. 8 round sable brush.

Step 3. Now I start to develop other parts of the painting. So far, the design is composed of convex hill shapes. Now I work into the water area with concave curves to set up another texture. If the paper is too dry, I moisten the sponge and tap some dampness into the paper. But I don't drag the sponge because I might lift off those first diagonal tones. If necessary, I also remoisten the paper with an atomizer spray of clear water. Now I mix variations of ultramarine blue, alizarin crimson, and burnt sienna, and using the 1″ and ¾″ (25 and 19 mm) flat brushes, I brush on the colors in sweeping curved strokes of varying lengths and thicknesses. Then, with a rich coating of ultramarine blue on the left edge of the larger flat brush and pure burnt sienna on the right edge, I twist the brush in a few quick flicks for the short waves in the lower right and center left. I do more pebbled mat board stampings on the central building, using cadmium yellow deep and burnt umber painted separately over the surface of the mat (a little wetter pigment to go into a drier area). I use it for the dark rock patterns under the wharf (ultramarine blue and burnt umber), including a couple of short edge stampings there. Water ripples are added with a few flicks of the no. 8 round sable brush.

Step 4. Linear impressions are now applied with edge stampings to block in some of the major shapes and forms. Since this is a contemporary painting and uses flattened space, I'm not concerned with perspective. Instead, shapes are developed here as simple side- and front-view patterns. Again, emphasizing design qualities, I'm now setting up angular shapes to contrast with the curves already painted. Applying Winsor red along the upper edge of a 1″ (25 mm) mat-board strip, and mixing ultramarine blue with the Winsor red along the rest of the edge, I stamp the lines of the masts in a slightly moist area. Additional dark edge stampings are applied (some slightly off register) to form other shapes: curved stampings are used in the sails and boat hulls, and tapered dragged stampings under the sail booms and under the boat hulls. Sometimes lines overlap or are lost (omitted), or spatial passages are left in. In two-dimensional paintings, it's important to leave open passages so that the eye can move easily in and out of shapes and patterns. Notice the light passages I've left in the hills and the water, and the open-line passages in the three sails. Negative patterns are also important: I dragged out the cool, negative shapes (ultramarine blue and burnt umber) under the wharf with a mat board edge, leaving the pilings as white paper.

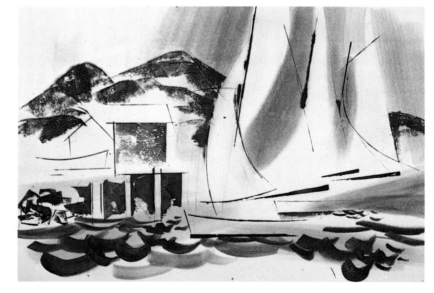

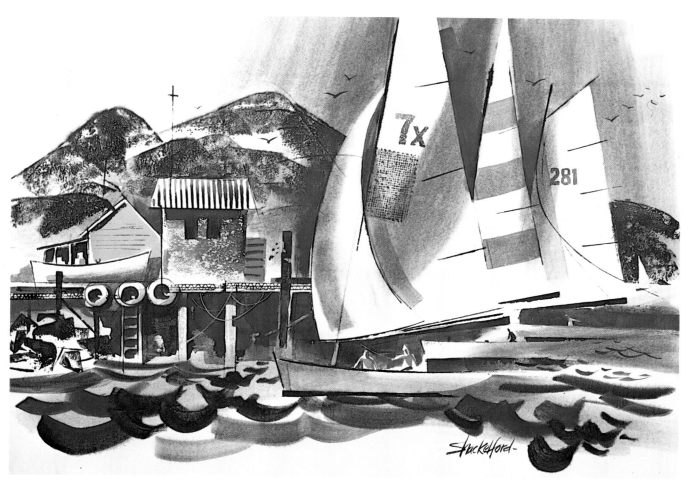

Coming In. The deck is created with a corrugated edge stamping. The roof is made with multicolored stamping of a flat sheet of corrugated paper that was striped with cadmium yellow deep, Winsor red, alizarin crimson, and ultramarine blue. A dark burlap wallpaper stamping is applied to the sail to suggest canvas, dried with a hair dryer, then brushed with a light glaze of diluted purple (ultramarine blue and alizarin crimson). The sail number is stamped with a reverse image painted on a pebbled mat board in new gamboge, Winsor red, and ultramarine blue tones. For contrast with the textures, I now add flat shapes. First, the building is painted with new gamboge, the complement of purple. Then,

purple stripes are added to the center sail. The shed and the planks on the yellow building are added with fine tilted-edge mat-board stampings. Thin, light, purplish washes are glazed over the wharf understructure, behind the buildings to push the hills back, between the main building and the sails, and on the job sail (I remoisten it first). Then I brush darker purplish blues under the sails, working around the shapes of the people. Then, I dip the no. 8 brush into pure, intense color—Winsor red, cadmium orange, and cadmium yellow light—for the tiny figures. I also place the strongest value contrasts there.

OTHER EXAMPLES

La Mission, *by Bud Shackelford*. Edge stampings are used in this painting to set up many space divisions of unequal sizes and shapes. In each of these areas, a different happening occurs, either in color, texture, detail, shape, or form. It's a study in contrasts—curves against angles, textures against flat shapes, rest areas and busy areas, form versus space, thin lines and thick lines, soft edges and hard edges, darks against lights, and lights against darks. Notice the variations in the size of the windows, doorways, and open passages.

Notice also the breaks in the lines for open-space passages. The eye can travel easily over the flattened surface of this painting through light passages and blended tone areas, and in and around most of the shapes and texture groupings. Also, throughout the painting there are many isolated focal points, flagged with intense colors. Pebbled mat-board stampings in various colors appear on the walls of the building. The color plan for this painting is an analogous one of warm colors that neighbor each other on the color wheel. (See Chapter 8 for more information on colors.) Only a few bluish colors are in the negative passages.

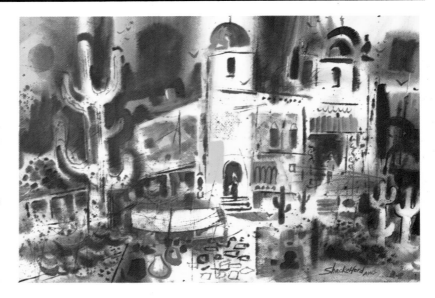

Cloud Cover, *by Bud Shackelford*. A tremendous contrast in surface textures and tensions is designed into this painting, where the massive sky of soft fused clouds contrasts with the angular textured hill forms, which are laced together with conflicting diagonal lines.

Several techniques are employed in this painting: the wet-into-wet technique for the turbulent sky; flat pebbled mat-board stampings in wet and dry areas for the grouping of mountain textures; linear mat-board edge stampings, some off register, overlapping, dragged, and tapered (by holding one end as a pivot and dragging the other). There are also multiple edging stampings in the lower right, and curved-edge stampings from the left foreground into the hills, and several two-color edge stampings. Finally, a little toothbrush splatter and slung paint is visible in the left foreground and up into the sky.

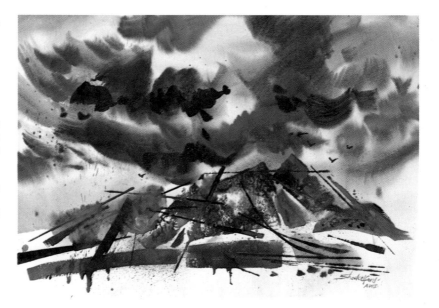

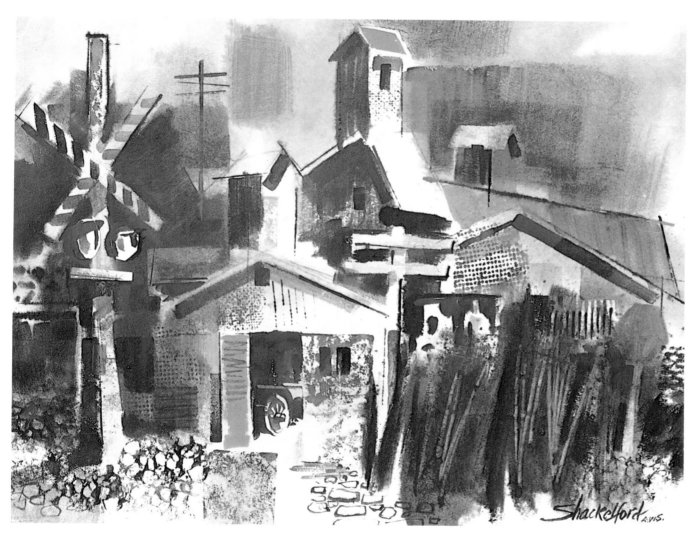

Freight Stop, *by Bud Shackelford.* Architectural subjects containing man-made buildings and structures are set up through rectangular washes placed here and there all over the surface, with some light open passages reserved. Major shapes and forms are set up with mat-board edge stampings, including a variety of big, medium, and small sizes. (Two flat mat-board stampings are to the right and below the center doorway.) Subtle distortions of shapes are intended to set up movement and tensions.

Much attention is given to cool negative passages, such as the space surrounding the railroad cross arms, the interiors of the openings in the doorways, and behind the red stop sign on the right. The subject is loaded with props typical of things you might see near a freight-train crossing. Some of these are seen as textures. In the previous chapter, we covered surface textures. This painting is loaded with them. Can you pick them out?

LIFT-OFFS AND SCRAPE-OUTS

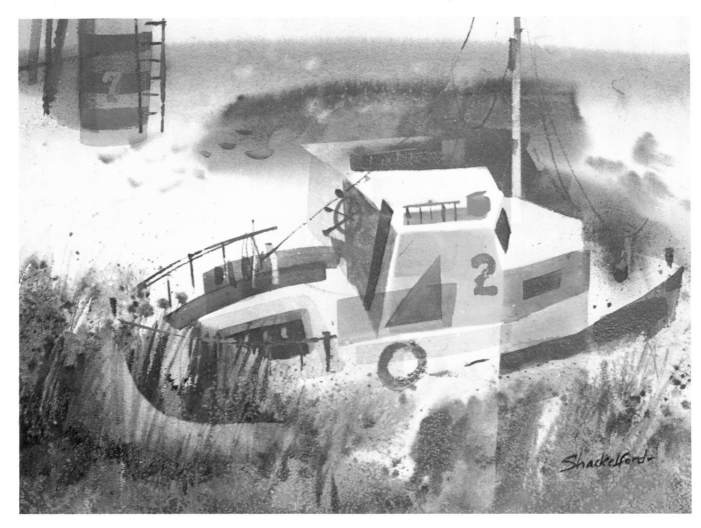

Ghost Boat, *by Bud Shackelford.* The ghostly double images and extended patterns in this painting give the effect of a "ghost boat" bloating in space in a marsh area Lift-off techniques with a moist sponge and pre-shaped tag board templates were used to create the double-image extension of the cabin into the upper dark area above, and to wipe out the space below the stern of the boat on the lower left. Two strips of tag board were used as templates to create the mast. The strips were separated to leave the proper width for the mast, and the mast was rubbed out with a slightly moist sponge. Care was taken not to let water seep under the templates. All these lift-off techniques were done when the painting was completely dry. The lift-offs created lighter patterns and shapes. Finally light-toned patterns were applied with a flat brush to extend the right cabin image down into the marsh grass and to extend the left cabin ghost pattern out to meet the lift-off pattern. Even though the painting is three-dimensional, the patterns are flat and appear as rectangular, triangular, curved, or distorted shapes, which make it contemporary and designy. All the colors in the boat are invented ones for excitement, and bear little relationship to reality.

Lift-off and scrape-out techniques are used to lighten areas, to wash out portions for changes or corrections, to create lighter textures or highlights, to soften edges, and to scratch out textures or details. They can be accomplished in both moist and dry areas. Hard-surface rag papers of 140-lb weight or more, such as Arches, Fabriano, and the Strathmore Gemini series, are best suited for these techniques, although hot-press, cold-press, and rough surfaces all work well.

Lift-offs of moist pigment with absorbent materials can be practiced in several ways: (1) lightly touching the moist pigment to leave a little of the impression of the type of material used, such as the folds of a piece of tissue, the texture of a paper towel, or the textures of various sponges (sponges must be cleaned in clear water and squeezed as dry as possible so that they'll absorb the moist pigment when lightly touched to the area); (2) pressing the same materials with more force to lift out more of the moist color; and (3) rubbing the moist pigment with either of the lift-off materials. Sharp edges can be created by using templates on dry paper, and hard-edged shapes can be lifted out of darker areas. In extreme cases, when paintings have been overdone and you want to return to an earlier stage, it's possible to wash off the excess pigment by lowering the entire painting into a bathtub, agitating it slightly, and lifting it out. You may be surprised and get a beautiful underpainting that can still be brought to a successful finish.

In addition to lifting off color, you can also scrape it out. Scrape-outs can be made in moist areas with plastic credit cards or pieces of mat board, using a squeegee process, and in dry areas with knives, scissors, or sandpaper.

MATERIALS AND TOOLS

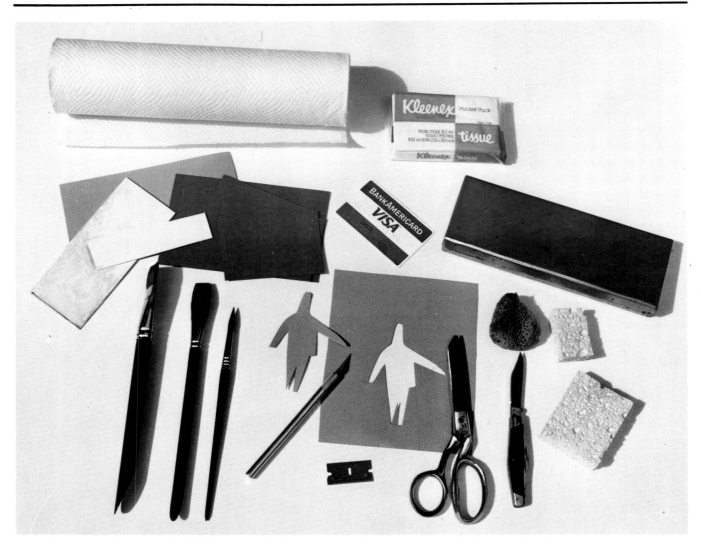

For practice with lift-offs and scrape-outs, you'll need the materials pictured in the photograph. They include a 1″ and ½″ (25 and 13 mm) flat brush, with tapered handles for scrape-outs; a no. 8 round sable brush; your watercolor palette; straight-edged mat-board strips or a credit card for squeegee effects; tissues, paper towels, and an assortment of small sponges for lift-outs; blotters for blot-outs; tag board for templates; and an X-Acto knife no. 3001, a razor blade, pocket knife, and scissors for cutting templates and for scratching and scraping out color.

APPLICATIONS

Paper Towel and Tissue Lift-Off. Using your 1″ (25 mm) flat brush, apply a flat coat of burnt umber to an area about 5″ × 7″ (12.5 × 18 cm), and practice these two sets of stampings while the pigment is still wet. Form a ball of a piece of dry paper towel and flatten the face of it by pressing it down on the table. Now lightly touch the flat towel surface to the left side of your wet surface in two places. The lift-offs will retain some of the wrinkled patterns. On the right side, lift the pigment off with a wadded tissue ball, rubbing the spots with a twisting motion.

Blotter Lift-Off. Blotters can be cut with scissors into any number of shapes and used to lift off a precise, flat image. Cut the blotter first and have it ready. Next, apply the pigment to the paper. Immediately lower the blotter in position without letting it slip, and press it down firmly. Don't let your finger touch the moist pigment. On narrow blotter extrusions, press with the end of a pencil or a screwdriver. Lift the blotter straight up, and you should have a clean-cut, light pattern.

Using Towel, Tissue, and Blotter Lift-Offs. For this example, you'll need burnt umber, a 1″ (25 mm) flat brush, and a 7″ × 10″ (18 × 25 cm) sheet of 140-lb cold-press Strathmore Gemini or Arches paper. Before starting the painting, cut out two triangular sail shapes from a blotter. Plan to work quickly.

Start by moistening the paper on both sides with a damp sponge. The simple mountain shape is painted first with thick, dark burnt umber; then the foreground water is applied in a lighter tone of diluted umber. Immediately press down the larger triangular blotter and then the smaller blotter for the two sail lift-offs. Next, lift off the paper-towel impressions on the left and right portions of the mountain and rub off the center curve in the mountain with a small wadded tissue ball. Now you can relax a moment. When the paper is drier, add the sailboat details and flick in the waves with the no. 8 pointed sable brush. Finally, cut a round blotter shape for the sun. Apply a light umber wash in one or two strokes with the large flat brush right across the dried mountain for the sky passage, and quickly blot out the round sun.

Brush Lift-Offs in Moist Areas. Use your 1″ and ½″ (25 and 13 mm) flat brushes and the no. 8 pointed sable brush. First, apply a dark coat of burnt umber to a sheet of watercolor paper. Pick up the ½″ (13 mm) flat brush, wet it in clear water, and squeeze it damp dry between your index finger and thumb. Stroke the brush over the moist paint to lift off pigment. Repeat as many times as necessary to lighten the impression, cleaning the brush in fresh water each time. For the final stroke, the brush can be quite dry (wipe it with a tissue). Now repeat the process with the 1″ (25 mm) flat brush, and finally with the pointed brush (on the right). You must work quickly, before the pigment has a chance to dry.

Brush Lift-Offs in Dry Areas. This time, apply a dark wash of burnt umber to a sheet of paper and let it dry completely. Now, following the same process as before, you'll discover that you can still lift pigment off with brushes. The main difference is that the brush must be cleaned in fresh water after each stroke or two, and many more strokes are necessary. It takes more patience, and you must be careful to follow the same track each time. When the brush strokes are finished, press a folded sheet of tissue over the impression for a final blotting.

Using Brush Lift-Offs in a Lighthouse Subject. This exercise is painted in three values of burnt umber. Begin with the light washes of the lighthouse and sky, working around the roof. Then paint the medium-value washes of the building and boat shadow and of the lighthouse porch. End with the darkest washes: the tree foliage, boat, and lighthouse shadow. Since the foliage is applied last, lift out the tree trunk and branches from the wet paint with the no. 8 round sable brush, and lift out the picket fence with the ¼″ (6 mm) flat brush before the paper dries. Now add a shadow to the central post and a darker bottom row of picket boards in the open area. Sharpen the posts when they're dry by repainting the darks up to the edges in places. Aim for a variety of soft and hard edges. By now, since the entire painting is dry, practice the dry lift-offs for the boards supporting the boat and the little window in the lighthouse shadow, using the no. 8 brush. Finally, paint in the dark window on the side of the building, which helps define the top of the main post.

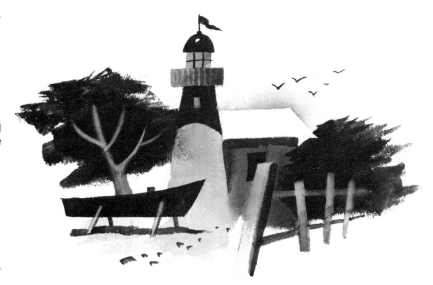

Lift-Offs with Templates. First, apply a dark coat of burnt umber to a sheet of paper and let it dry. Then cut out several templates from any stiff paper (such as tag board or filing cards) with a scissors or X-Acto knife. Both the piece with the cutout opening and the leftover piece will be used in this exercise. Place the template opening over the dark area and, working with a small, moistened, clean sponge, wipe the pigment away. Rub from the edges of the template toward the center, being careful not to let the water seep under the template. Try lifting more pigment from the upper areas for a graded effect. Note that you can also form straight lines with two cards (upper left) by separating them at the edges and lifting off the space in between.

Lift-Offs with Template Masking. Now, instead of using the opening of the template, use the cutout piece that was left over. This time, you'll mask the area and lift off the space around it. Again, moisten the sponge in clear water, squeeze it nearly dry, and wipe the paint from the positioned template into the surrounding area. As before, avoid any seepage under the template and always wipe away from the template edge. You can also use corners or edges of cards to mask areas for lift-offs, as shown on the left. This simple lift-off method is handy for making roofs of buildings appear in darkened areas.

Using Template Lift-Offs for a Landscape.
Paint a hill on dry paper, using your 1″ (25 mm) flat brush and a medium tone of burnt umber. Add dark shadows, and darken the lower right portion of the hill, where lift-offs will occur. Since the figure is too small for a template, paint around it. Next, with the no. 8 pointed sable brush, stroke in a row of dark grass across the foreground, letting it fuse into the dark hill area. Now cut out separate template shapes for the front of the house, the side of the house, the overlapping shape in the foreground, and the billboard. Use the openings of the templates for the front of the house and the billboard, as in the first example above. After several rubs, you'll discover that the sponge will create an even tone in the white paper portions too.

Next, use the cutout template parts to mask the dark roof and side of the house and wipe off the space into the hill and the window, as in the second example above. Cover the white ground with a separate card while sponging. To make the telephone pole, mask the hill with two tag-board cards on either side of the pole, and wipe off the color with up and down strokes, right up into the sky and below into the grass. Square off the top with the no. 8 brush, and add the crossbars, the little fence, and the dark windows.

Brush-Handle Scrape-Outs. The tapered handle of flat Aquarelle brushes is perfect for scraping out pigment. A pocket knife will make finer scrapes. To try these scrape-outs, start with a wash of burnt umber, as in previous exercises. The trick is to let the pigment start to dry and to scrape out the lines just before it does. If the pigment is too wet, the lines will fill in again. Notice that you can also drag pigment from the painted areas into the clear white areas.

Credit Card or Mat-Board Scrape-Outs. Any stiff card can be used to scrape out pigment with a squeegee action. You can use the end or side of a plastic credit card or precut pieces of mat board for a variety of widths. Let the pigment get almost dry, then scrape out the desired width with the edge of the card. Slant the card in the direction of the scrape. A puddle of darker color will collect at the end of the stroke. You can leave it, lift it off with a tissue, or blend it into the original background.

Scraping Out a Variety of Objects. Start with your 1″ (25 mm) flat Aquarelle brush and burnt umber. On slightly moistened paper, paint in a dark foreground and then add the dark foliage pattern of the tree. Move the flat brush sideways to the chisel point with sliding upward swings to get the crisp foliage edges. Next, scrape out the center building from the bottom upward with a credit card. Leave the dark pool at the end; it will become a shadow under the roof. Cut a piece of mat board to the width of the second building and drag it upward. With the tapered handle of the Aquarelle brush, scrape out the fence and posts. Now the foliage should be partially dry. Scrape out the curved trunks and branches with the Aquarelle brush handle and scrape out a few flicks of grass with a pocketknife. When the paper is completely dry, wash in a light-toned sky right through the tree foliage, working down and around the roofs, forming a crisp outline, and over the right post. Add the rest of the details —the birds and fence wires—with your no. 8 pointed sable brush.

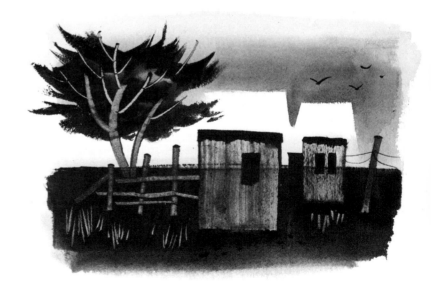

Knife and Razor Scrape-Outs. These scrape-outs are done in dry pigment areas. Coat the paper with a dark application of burnt umber and let it dry completely. On a whetstone, sharpen your pocketknife blade, working toward the tip. Remember, always keep it sharp. Scratch the pigment off the paper by dragging the blade near the point sideways. You must dig right into the paper, scratching the pigment off. The closer you are to the tip, the finer the line. The corner edge of a razor blade produces the finest lines. If you're using thin paper, be careful not to cut through it.

Sandpaper Scrape-Outs. Again, coat a sheet of paper with dark burnt umber and let it dry completely. Use medium-coarse sandpaper on the left-hand side of the paper, sanding in several directions, and easing up at the extremes. Now switch to very coarse sandpaper for the right-hand side, scrubbing with up and down strokes.

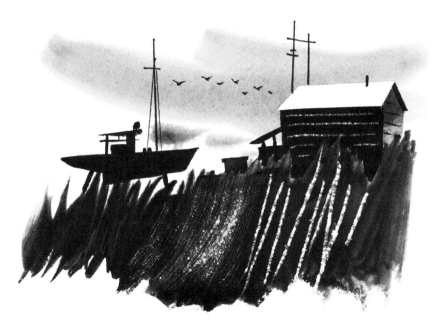

Using Knife, Razor, and Sandpaper Scrape-Outs in a Seascape. Paint this subject in three values of burnt umber and let it dry completely before scrape-outs are added. Cut a piece of masking tape to the shape of the roof to mask out this white area. Then start by moistening both sides of the paper with a sponge. Fuse in a light-toned sky and a dark foreground, working wet-into-wet. When this is dry, add the hard-edged buildings, boat, poles, mast, and details. Strip off the masking tape for the white roof. Now, using a pocket knife, scrape out the larger blades of grass. Then, with a razor blade, scratch out the fine white lines on the building. Finally, use the coarse sandpaper to scrape out the finer curved lines of the grass.

TIPS

1. For lighter lift-outs in moist areas, remoisten the lightened portion with a damp sponge or tissue and go over it again with the lift-off material.

2. Laundry bleach can be used to further lighten an area. Dilute the bleach in a small pan of water, dampen the lift-off material with the solution, and apply.

3. Clean moist sponges are also useful for lift-offs. A round natural sponge will leave fused edges, and a small, square kitchen sponge will leave crisper edges.

4. Damp sponges are needed in working with templates. However, when you squeeze most of the moisture out of the sponge, it leaves your hand and fingers wet. Be sure to dry your hand before continuing, to prevent drops of water from running onto your work.

PROJECTS

1. Plan a large mountain scene with a medium-toned foreground. Keep the masses large for lift-off practice. Use a half sheet of 140-lb cold-press watercolor paper. Precut blotter shapes for sheds, silos, and other objects, and cut a template opening for a large barn. Also, cut a template to be used as a mask for the side of a smaller building. Choose a limited palette—for instance, burnt umber, new gamboge, and cobalt blue. Use bluish colors in the sky area, brownish ones in the mountain, and yellowish ones in the foreground, neutralizing the colors with each other. Since all lift-offs will be done while the pigment is still moist, you may have to paint it in two parts. Apply a light sky first and then the dark mountain mass next. Into this mass try a series of lift-offs with paper towels, tissues, sponges, and rags. Quickly blot out the sheds and silos. Lift out posts and picket fences at the base of the mountain, along with tree trunks, with your brushes. Just have a ball!

Now practice dry lift-offs. Paint in your medium-tone foreground, maybe suggesting massive grass shapes and textures, and let it dry. Then use your open template to lift out the larger barn shape from the mountain, working partially into the foreground. Use your cutout mask template to place the side view of the building on the hill or next to the barn. Refer to all previous exercises first to formulate your procedure.

2. This time we'll concentrate on scrape-outs with brush handles, mat board, credit cards, knives, razors, and sandpaper. On a half sheet, using several colors of your choice, plan a large, dark foreground from which buildings and massive tree trunks will be scraped up into the sky area with cards and mat board. Paint in the foliage masses first, to receive the scraped-out trunks. Fences, branches, and twigs will be scraped out with brush handles. Finish the painting as creatively as you can, then scrape out line details with your knife and razor blade. Also, look for places where you can use sanded passages, such as the grass. How about sanding out light clouds in a toned sky?

DEMONSTRATION

Step 1. This painting will emphasize lift-offs and scrape-outs. Arches and Strathmore Gemini 140-lb cold-press rag papers have an excellent surface for these techniques. I select the Strathmore paper for this demonstration. I pencil in the main lines of the painting on the paper separating the subject into three planes: a foreground, a middle distance of building patterns, and a background of hills and sea. After thoroughly moistening both sides of the paper, with the 1½″ (4 cm) flat brush, I mix a pool of new gamboge on the palette and apply this to the foreground plane. Then I dip into raw umber, mix it with the leftover new gamboge, and apply it to the sky in vertical strokes behind the buildings. Then, mixing ultramarine blue and alizarin for a purplish tone, and with a touch of the gamboge mixture, I apply a rolling stroke for the distant hill. Finally, I add more alizarin and gamboge to this purple and paint the balance of the hills in and around the buildings on the left. (Mixing the same colors together in varied proportions relates the colors in a pleasing way.)

Step 2. With scissors, I cut a double-sail shape out of a blotter and lay it aside. Switching to the 1″ (25 mm) flat brush, I mix richer and darker purples (alizarin and ultramarine) and apply them to the hills with firm, direct strokes, leaving some areas white. Adding a touch of burnt umber to the purple mixture, I extend the distant dark hill over the waterline. While this area is wet, I position the precut blotter over the hill and blot out the two sails. Then, with rich purples and touches of new gamboge and raw umber, I continue painting the lower hills down to the crisp roof shapes. Since the cool purples push back, they cause the roof edges to pull forward according to the push-pull theory. Next I paint the foliage of a small cypress tree with a mixture of viridian green neutralized with burnt umber and a ¾″ (19 mm) flat Aquarelle brush. I work in short, brisk strokes from left to right, filling in the center with solid color. Then I paint the shadow with the same brush, using a dark gray mixture of ultramarine blue and burnt umber. I scrape out the trunk and main branches with the tapered Aquarelle brush handle, using firm, brisk strokes. I scrape out the thinner branches with my pocketknife.

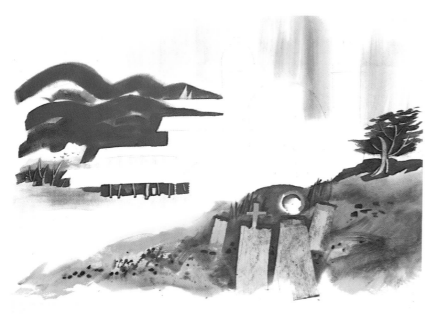

Step 3. I rewet the trees and apply a mixture of new gamboge and raw umber to the lower foliage, letting it fuse into the white areas. I also paint the side of the long building on the left with raw umber. Now I paint the crisp negative darks under the trees and long shed with the flat Aquarelle brush, using mixtures ranging from dark grays to cobalt blue, quickly lifting out a few light tones with wadded tissue and scraping out the trunks, branches, and posts under the shed with the brush handle. The massive foreground area is painted next. First I cut a few pieces of mat board to the various widths for the headstone markers. Then, rewetting the foreground with the 1″ (25 mm) flat brush, I paint in the autumn grass with rich variations of new gamboge, cadmium orange, burnt sienna, and burnt umber. I leave a circular area over the tapered headstone white. Now I wash in a neutral purple (alizarin and ultramarine) to darken the area where the scrape-outs are to occur. I scrape out the headstone with a credit card, working from the bottom up, leaving the squeegeed pigment to collect in a dark pool at the end of the stroke; then I scrape out the cross with the tapered Aquarelle brush handle. The other headstones are scraped out with various sizes of mat board.

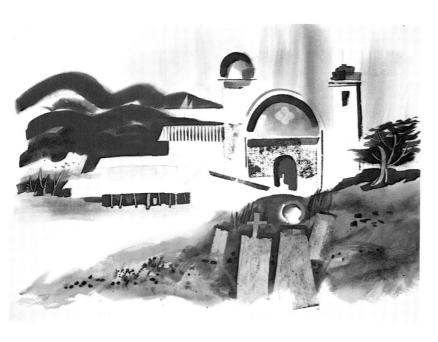

Step 4. I now concentrate on the mission buildings. A multicolored, corrugated flat stamping creates a roof, and pebbled mat-board flat stampings of varied gamboge and purplish colors are made on the faces of the tower and main chapel. Curves and edge stampings form some of the building shapes. Two different types of bell-tower domes are added: The left dome is a round form of rich cadmium orange, burnt sienna, and dark purple, applied to a remoistened area so that it fuses; and the right dome is more angular and casual, and has a reddish purple color (more alizarin and less ultramarine), with a black accent. I first cut the clover-shaped window of the chapel out of a blotter. Next, I brush purple into the area, press the precut blotter into position, and lift out the clover pattern. When it's dry, I add the shadows. Then I paint in the arched doorway with burnt umber and cobalt blue, working around the white figure. I add a dark blackish shadow on the left side of the doorway. Finally, I drag a mat-board edge stamping of burnt umber and phthalo blue for the lines of the diagonal roof to the left of the doorway.

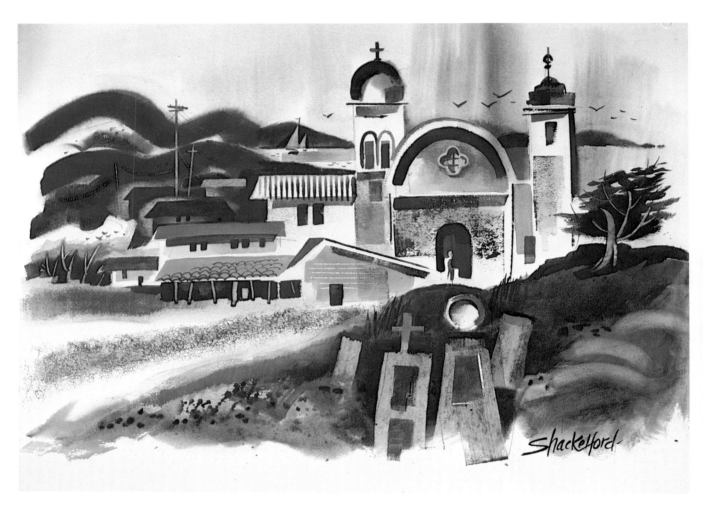

Carmel Mission. Additional roofs of Winsor red, orange, and burnt sienna, along with a cadmium yellow deep building, are added for color. A tile texture and other details are added, including arched windows, finishing touches on the clover window, and Winsor red and orange touches on the figure in the doorway. With 1″ and ¾″ (25 and 19 mm) flat brushes, I pattern and glaze additional parts of the buildings, and finish the hill and water behind the right tower. A light cobalt blue wash suggests the distant sea, and a few dark flicks complete the sailboats. Doors, windows, and a few rich cobalt blue reflections, are added. Now for the final lift-offs. Using the ¾″ (19 mm) flat Aquarelle brush and clear water, I make several curved sweeps in the right foreground to loosen the pigment, then blot it with a tissue, repeating until sufficient pigment is removed. Then I lift out the dark buildings in the dark purple hill area, using tag-board templates, including an open template for the lighter house and cutout pieces to mask the darker houses. The tall poles are lifted out between two cards, and the cross arm is lifted out with the pointed brush. Finally, a razor blade is used to scratch out telephone lines and the board textures on the central yellow building.

OTHER EXAMPLES

View from Wave Street (Stage 1), *by Morris J. Shubin.* These two stages provide an interpretation of Cannery Row in Monterey, California, in the flattened contemporary style of Morris Shubin. Varied patterns of positive shapes and negative passages with a smattering of roofs, signs, figures, and other details are shown in this first step. It starts as a complementary color scheme, with purples and yellows dominating. Morris states: "The façade form was painted in first. Color was added when wet for fusion, then changes were made with lift-offs, rearranging the structure from original sketches."

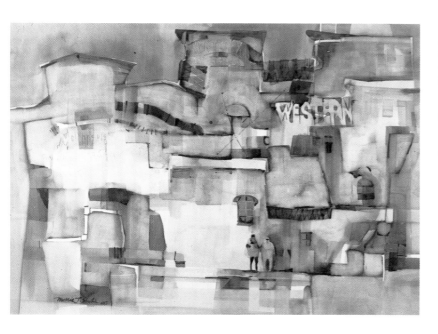

View from Wave Street (Stage 2), *by Morris J. Shubin.* Morris Shubin continues: "This is the same painting. Additional areas were lifted off again; and when dry, I went back in with more glazes for a luminous, transparent feeling. Shadows were painted in last to reinforce the movement from the bottom left to the top right of the painting. I painted it on 30″ × 40″ (76 × 102 cm) mounted paper on Crescent board, Strathmore Rough no. 112. No opaque whites were applied. I used the white of the paper only."

CHAPTER FIVE
PAPER TORTURE

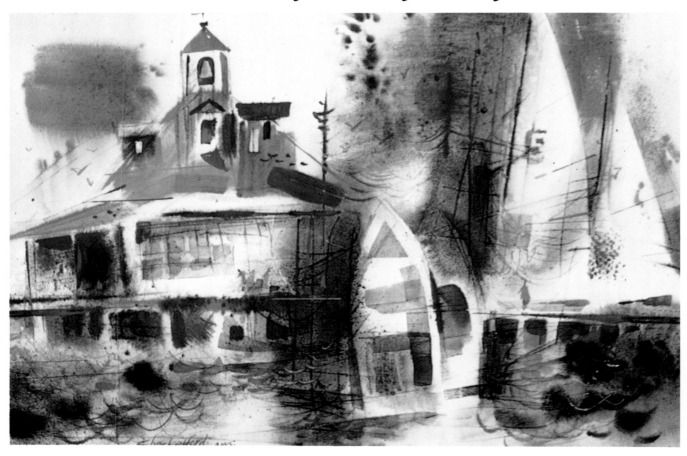

Boathouse, *by Bud Shackelford*. The shapes in this abstract painting were planned as flat patterns of front, side, and top views, all in the same composition. Angles are played against curves, soft edges against hard, and flat shapes against textured areas. The entire painting is animated with tensions and distortions. Note the handling of the boathouse roof. Initial patterns were set up by knife scratches, then the brushstrokes were applied in conflicting directions, leaving lots of open white areas. The subject was scratched out with threadlike knife scratches. These marks darkened when light washes were painted over them. They also knit the painting together as a whole. (Knife-scratching techniques will be discussed in more detail in this chapter.) In addition, note that several off-register edge stampings complete the shapes; that each window alcove is handled differently; that the dark diagonal on the lower right-hand side is an abstract directional force; and that the color plan is triadic, with reds, yellows, and blues dominant.

So far, we've covered many experimental ways to apply or lift off pigment for exciting painting variations. Now let's explore some things we can do to the paper itself.

With sharp instruments, the paper can be scratched with either preplanned or abstract shapes and patterns. It can also be abraded in various strokes and patches with sandpaper or roughened with a wire brush. Any of these areas will show up clearly when light or medium washes of color are applied over them.

This approach to painting often can replace "penciling in" the subject, and the character of a scratched line may be interesting in itself. As a side benefit, when viewed behind glass, a painting with obvious scratching on the surface will certainly be identified as an original watercolor and not a print.

The paper also can be creased or crushed in order to set up abstract lines, space divisions, or abstract shapes and patterns from which subjects can be developed. When pigment is washed over these folds and creases, it either settles into the recessed valleys or is absorbed into the roughened ridges and darkens these areas. Creasing and crushing is most effective on 90-lb to 140-lb rough or cold-press rag paper. Afterward, it can be thoroughly wet on both sides and stretched too, if you wish.

Sanding must be done on dry paper only; and though scratching is usually done on dry paper also, it can be done on wet paper, after painting has begun. But you must be especially careful to avoid tearing the paper, since it's weaker when wet. Most watercolor papers of good rag content and a variety of surfaces can be used for scratching and sanding, though you have to be careful when using thin sheets.

MATERIALS AND TOOLS

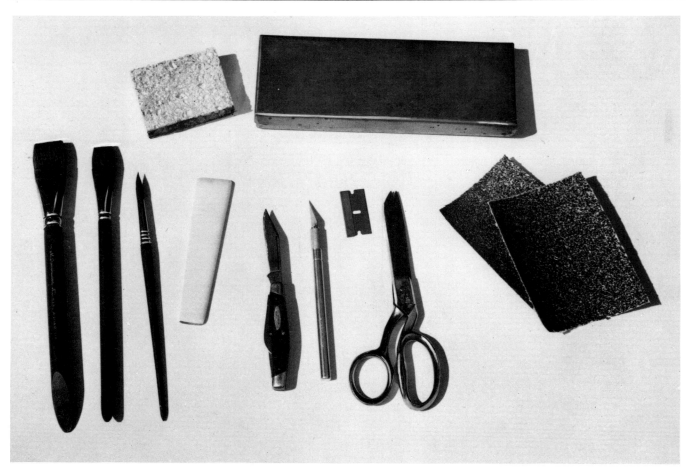

Assemble the following tools for paper torture techniques: 1″ and ¾″ (25 and 19 mm) flat brushes, a no. 8 round sable brush, watercolor palette with fresh pigments, kitchen sponge or burnisher (formerly made of bone, now of plastic), sharp pocket-knife, X-Acto knife, single-edged razor blade, scissors, and extra-coarse or medium-coarse sandpaper.

Heavy scratching is done with your scissors or pocketknife, and finer scratches with the X-Acto knife or razor blade. (Your pocketknife must continually be kept sharp with a whetstone.) Scratching will also be done with sandpaper. To make distinct scratches with sandpaper, use an extra-coarse sheet. For medium scratches, use

a medium-coarse sheet. Fine sandpaper is ineffective.

Bones are designed primarily for commercial artists who use them for burnishing down self-adhesive art types and lettering, Zippatone masks and patterns, and so forth. But for our purposes, the bone burnisher has two uses: creasing the paper or smoothing it down. Creases in watercolor paper are made by folding the paper and rubbing the side of the bone down hard over the fold to form a tight crease. Burnishing or smoothing down a portion of rough-surfaced watercolor paper is done by rubbing the tapered end of the bone with firm pressure over the rough surface several times. Let's examine these applications now in more detail.

APPLICATIONS

Scratching. On 7″ × 10″ (17.5 × 25 cm) pieces of rough or cold-press paper, practice several scratching variations with different tools. First, sharpen your pocketknife and, with lots of pressure, scratch straight lines, curved lines, and various shapes into the paper. Drag the blade crossways to the edge of the paper, and note that by tilting the blade closer to the point, the lines will be thinner. Also scratch some very thin lines with the razor blade and X-Acto knife.

Now mix a pool of medium-value burnt umber and brush it over all the lines. To fill the scratches, move the brush back and forth over the lines in different directions with plenty of wet pigment. Since the scratches absorb more of the pigment than the surrounding paper, darker lines appear there instantly. While the paper is wet, try making a few more scratches, and again paint over them.

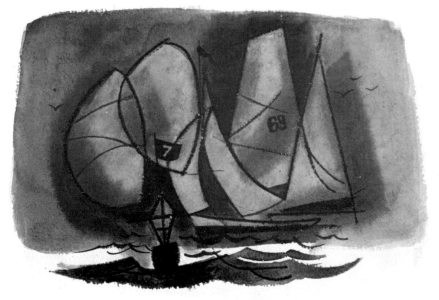

Scratching in a Seascape Subject. To break away from the usual method of sketching in your subject with a pencil, use this approach to loosen you up and produce a linear effect with an interesting character of its own. First, scratch in the essential lines forming the sail shapes, boat hulls, buoy, and waves with your pocketknife. Then add thinner lines within the sails with the razor blade. Next, brush a light umber wash over the sails with your 1″ (25 mm) flat brush, working the tone well into the scratches. All the scratched lines will instantly show dark. Now mix a darker value, and paint wave shapes in the lower portion of the painting with the ¾″ (19 mm) flat brush, leaving a little white separation. The wave scratches will appear. Add some of the same darker tone in the negative passages adjacent to the sails, as shown. Finish by painting the buoy, flags, birds, and number on the sail with the no. 8 round sable brush.

Sanding. Practice sanding textures on cold-press sheets cut to 5″ × 7″ (12.5 × 17.5 cm) with extra-coarse and medium-coarse sandpaper. First, sand a few vertical strokes on the left side of the sheet with the extra-coarse sandpaper, applying firm pressure. Then change to the medium-coarse sandpaper and sand the center area with a circular motion, pressing firmly. Sand the center of this circle thoroughly a number of times. Next, sand a few vertical strokes on the right with the medium-coarse sandpaper.

 Now with your 1″ (25 mm) flat brush, apply an even wash of medium-value burnt umber over the entire surface. All textures will appear immediately. Work the pigment well into the textures by going over them several times in different directions.

Sanding in Textured Areas. On the dry paper, first sand the grass area with vertical strokes, using very coarse sandpaper. Switching to medium-coarse sandpaper, sand the sun design in circular strokes and indicate the roof with horizontal strokes. Wet a rectangular length of masking tape and apply it over the white portion of the house to mask it. Next, mix a medium-light tone of burnt umber, enough to completely cover the entire area, and brush it over the surface in various directions. Work the wash well into the sanded areas to bring out the textures. If you wish, you may apply a slightly darker wash over the sanded areas only and wait for the paper to dry before retoning the roof. When dry, strip off the masking tape to expose the white house and add the fence, posts, poles, windows, and porch with the no. 8 round sable brush.

Paper Creasing. Creases can set up vertical and horizontal space divisions and diagonal conflicts. For this exercise, use a 5″ × 7″ (13 × 18 cm) section of 140-lb cold-press paper. Crease one line at a time by folding the sheet and pressing the fold into a tight crease with the bone burnisher. Keep the crease inside the area to be painted. As you create creases similar to those pictured, burnish varied lengths. Fold some creases outward and some inward. Now flatten the creased paper by rubbing the surface with the side of the bone. Next mix plenty of medium-tone umber wash and brush it over the entire surface, going over it several times. Let the pigment settle into the creased valleys. The raised ridges will also absorb pigment. When it's dry, dark linear impressions will remain.

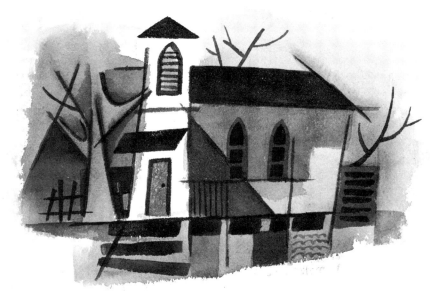

Creasing to Set Up Abstract Subjects. There are two approaches to this process. One is to have a subject in mind and form the creases to conform to your plan. The other is to arbitrarily crease and fold the sheet in numerous vertical, horizontal, and diagonal space divisions with varied lengths of creases and let these patterns suggest a subject.

If your painting is a half sheet (15″ × 22″/38 × 55 cm) or larger, it's best to wet both sides of the paper to flatten it out. The deeply creased impressions will still remain in the wet paper, and when the first washes are applied, the abstract patterns will emerge and suggest a subject.

Here, the paper is creased to conform to a specific shape, and the subject is painted using the abstract patterns of these creases. First, crease a 5″ × 7″ (13 × 18 cm) piece of cold-press paper to the shape of the church. Then apply a light burnt umber wash on the dry paper, reserving the white steeple section. Next, with the ¾″ (19 mm) flat brush, add darker tones between certain creases to isolate one pattern from another, such as those across the lower foreground and on the broad side of the building to set up a sunlight effect, the large diagonal shadow on the church, and the negative passages surrounding the tree shape on the left. You can also strengthen some creases with edge stampings. Then darken the roofs and add the details with a no. 8 round sable brush.

Paper Crushing. Use either 90-lb or 140-lb 5″ × 7″ (12.5 × 17.5 cm) cold-press paper for this exercise. (The 140-lb paper will require more force to crush and may be a little difficult to work with.) Wrinkle and fold the paper again and again, including diagonally, and crush by stepping with your full weight on the folded paper. (To get large and small crushed patterns, you'll have to wrinkle and fold parts of the paper into many different tiny wrinkles and step on each section separately to crush it.) Now open the paper and rub it flat with the side of the burnishing bone. Then mix a puddle of medium-value burnt umber and wash it over the entire surface with your 1″ (25 mm) flat brush. The pigment will settle into the valleys or be absorbed by the raised raw ridges, and dark abstract patterns will appear.

Crushing Paper for a Seascape Subject. Using the same size and weight paper as above, crush most of the small patterns into the center horizontal area, working from left to right. Then, cut masking tape into triangles and mask out the two white sails. Now you're ready to start painting. Mix up a medium-light umber wash and allow it to settle into the folds and creases of the paper and dry. This sets up the dark linear patterns. Next, with the ¾″ (19 mm) flat brush, paint darker umber tones in and around the various patterns and out to selected silhouettes for the three major mountain shapes. Use a slightly darker tone in the left-hand foreground pattern to separate the land from the water area, and be sure to darken the area behind the two sails. Let everything dry and then lift off the masking tape. To finish, add the tones in the sails and finish the foreground rocks, hull details, shadows, waves, and the dark lines in the hills with the no. 8 round sable brush.

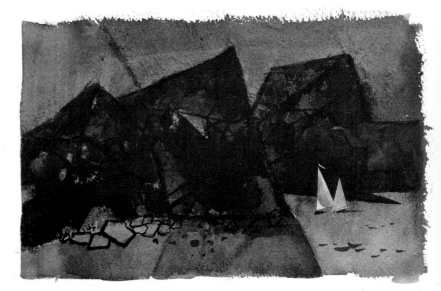

TIPS

1. Scratch the paper with enough pressure on your pocketknife blade to raise visible ridges. Make sure the blade is sharp.

2. If you accidentally cut or tear through the paper, push the torn parts together and tape the back. Don't use masking tape or any tape with colored dyes, as it will eventually stain the paper. White self-adhesive tape can be used, and white rag-paper patches applied with acrylic medium or flour paste are excellent.

3. Try using a stiff wire brush for multiple scratches and surface mutilation effects.

4. When folding and creasing papers, overlap some creases, stop some creases short of others (leaving open passages), and vary the space divisions between the creases.

5. After the watercolor sheet is creased or crushed, it can be completely moistened on both sides and stretched in the usual fashion, with gummed tapes. The creases will still be effective when you are ready to start painting.

6. Remember that your painting will be framed behind glass, so this will also flatten out major folds, wrinkles, or curls in the finished painting.

7. When burnishing portions of rough-surfaced paper with the bone, press hard on the tapered end to flatten the surface smooth. Color washes applied over this area will have a distinctly different appearance from the unflattened rough surface surrounding it.

PROJECTS

1. Select one of your older paintings that started with a substantial amount of pencil drawing, and do another version. This time, scratch the subject design into the watercolor sheet with a pocketknife, emphasizing strong verticals, horizontals, diagonals, and curves. Next, sandpaper some areas for grass or any portions where you visualize the possibility of a texture change. Plan a simple warm or cool color selection in analogous colors. Start with light washes over most of the surface, leaving some whites. The basic design will jump right out as the scratches turn to darker values. Develop the painting by using any of the experimental techniques from previous chapters that you may find useful.

2. Fold and crease a sheet of 140-lb cold-press watercolor paper with many combinations of verticals, horizontals, and diagonals. Include longer creases for space divisions, and numerous short creases going every which way. Overlap some of them. Fold some forward and some backward. Crease lines deeply with strong pressure applied to the burnishing bone. Next moisten the paper thoroughly on both sides, tack the four corners and start color washes. Plan an analogous color scheme, either warm or cool, the opposite of that in Project 1.

When the abstract patterns emerge, ask yourself if they suggest a subject. If not, turn the paper around or upside down and see if a subject is suggested now. If it is, bring the subject out when you paint. But if a subject still hasn't suggested itself, decide on one and force it into the abstract patterns set up by the creases. Develop shapes and patterns from many of the lines already created, and use values and colors to bring out the subject. Let other patterns become negative passages. Concentrate on flatter shapes and forms. Apply textures described in previous chapters to appropriate areas. Work toward an interesting surface combination of patterns, colors, tones, and textures as you develop the subject.

3. Create a huge foundation of rocks by using the crushed-paper technique, placing trees and a tiny village along the top. Use neutral colors in the massive rock area and richer colors in the village. One side of the rock hill may drop down to the sea for another texture variation.

DEMONSTRATION

Step 1. Since I prefer a creative approach to painting, I often start by making a number of small sketches as a plan and consult them as I work. In that case, I don't pencil in a drawing on the watercolor paper, but instead I let the painting develop freely during the initial stages. A favorite plan is to scratch a few major shapes onto the watercolor sheet with the sharp edge of a pocketknife, raising ridges that will pick up the first light washes as dark linear tones. (See, for example, Step 1 in the Chapter 3 demonstration.) Here I not only scratch the paper with a sharp knife, but I also make patterns with coarse sandpaper to set up the subject.

As always, the main idea—and the point of this book—is to let spontaneous things happen, creating as you go along. I may provoke exciting color accidents by dipping a flat brush into two or more colors, then twirling it into a wet area; or by mixing rich colors together on the moist paper rather than on the palette; or by dropping or slinging pigment into a wet area; or by using salt or other processes that will be described later. As you are surprising yourself with color, shapes, and textures, you're also guiding the painting toward a designed subject.

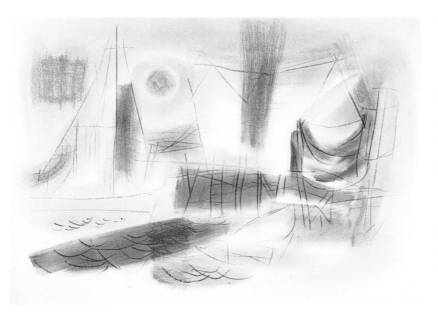

Step 2. I use a full sheet of Strathmore Gemini 140-lb cold-press rag paper. Referring to the sketch, I loosely and quickly scratch in the major lines with a sharp pocketknife, casually letting the strokes overlap or protrude. With coarse sandpaper, I now scratch vertical accents through the shack into the sky, next to the boat mast, and in the water below the sun. Then, switching to medium-coarse sandpaper, I sand a circular sun, a half curve to the left of the boat cabin, a rectangular pattern above in the sky, and an accent in the sky that follows the contour of the roof. Moistening the sheet thoroughly on both sides, with the 1½″ (4 cm) flat brush, I apply a light wash of ultramarine blue (with a little phthalo blue and raw umber), reserving a few whites. All the scratched and sanded areas immediately appear. Mixing a darker value of ultramarine blue with a touch of alizarin crimson and burnt umber, I brush a powerful diagonal stroke through the knife scratches in the water on the lower left to act as a visual lead-in. Mixing more burnt umber into the same color, I blend in a few folds on the hanging net. Switching to a 1″ (25 mm) flat brush, I wash phthalo blue with a little ultramarine under the wharf and over the vertically sanded areas. Then I lightly circle the sun with ultramarine blue and burnt umber for a stylized halo.

Step 3. Now I attack the deep negative passages under the wharf. With the ¾″ (19 mm) flat brush, I mix rich combinations of ultramarine blue and burnt umber and crisply paint the openings between pilings, including one *X* brace, leaving a few lighter values. With the tapered handle of the brush, I scrape out the other *X* brace and add a few thin posts. Notice that all the spaces are unequal; even the pilings are planned with variations. On the left, the darks cut out the shape of the boat hull and an abstract figure, along with the front edge of the cabin. I also darken the side of the shack with burnt umber and ultramarine blue, add a light shadow in the water next to the rowboat, and apply dark ultramarine blue waves in crisp, sweeping strokes. These stylized curves are designed to offset the many angular shapes that will later dominate the painting.

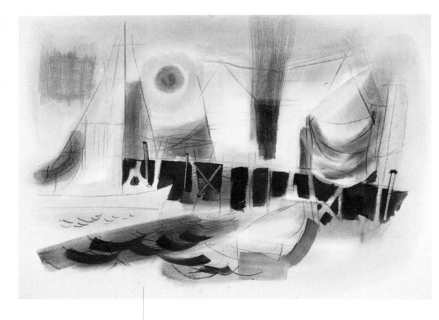

Step 4. A triangular area of neutral flat gray wash (burnt umber with a touch of ultramarine blue) is painted on the side of the shack to complement the two stamped textures that will come next. First, a burlap stamping is pressed into the net, and then a multicolored corrugated stamping (with areas of cadmium orange, alizarin crimson, and burnt umber) is applied horizontally to the side of the shack. (I masked off the net and net shadow with a piece of typing paper before applying the corrugated stamping.) Finally, I stamp the rocks with a Swiss-cheese sponge and indicate the water ripples on the left with textured packing paper.

Mixing a warm value of cadmium orange neutralized with a little ultramarine blue with the ¾″ (19 mm) Aquarelle brush, I paint a flat box on the left of the shack and a touch in the pilings above. Using mat-board edge stampings, I further define the major shapes of the two boats, shack, and roof. The wharf deck line is suggested with corrugated-board edge stampings. With dragged and stamped edges of ultramarine and cobalt blues and burnt sienna, I create the large piling on the far right. Finally, I add a few thin waves with a no. 8 round sable brush.

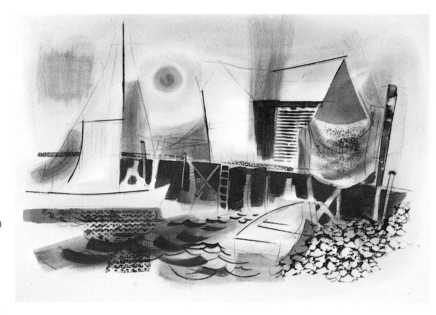

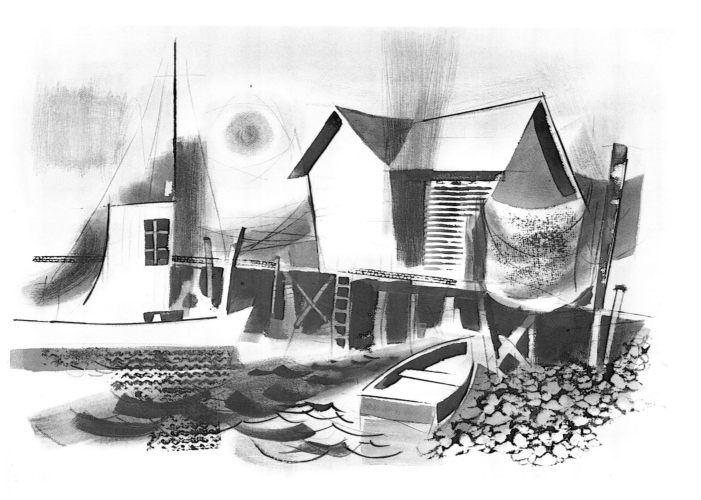

Step 5. In this stage, I add darker values of ultramarine neutralized with burnt umber to create the net behind the tall piling, the gable roof, and the shadow under the boat and to strengthen the negative passages around the boat cabin. I also scrape out a white spot for the headlight on top of the cabin. A darker mixture of the same color is applied with the ¾″ (19 mm) flat brush for shadows under the eaves and in the rowboat. The flat stern of the boat is painted with cadmium orange neutralized with a little ultramarine blue. Next I paint in the rectangular boat cabin window with thick cobalt blue and scratch out the panes with the handle of the Aquarelle brush. I also add a thin glaze of diluted phthalo blue over the rock textures.

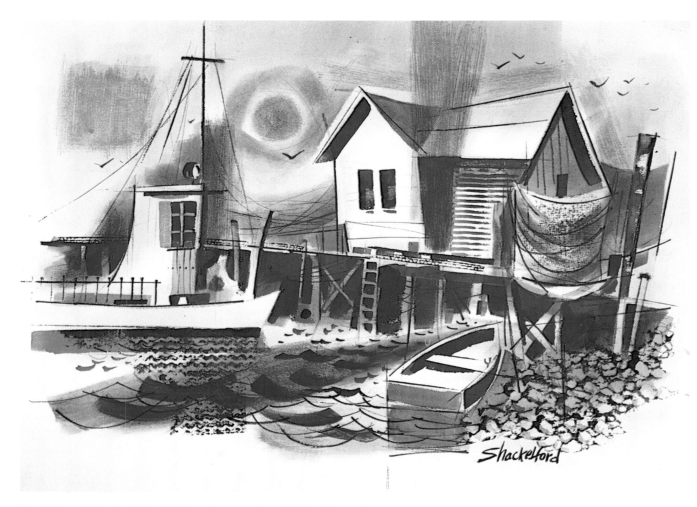

Wharf Shack. Now I add the finishing touches. The trick is not to overpaint or include any unnecessary details. I want to retain as much of the spontaneity of the original sketch, including the distortions, scratches, and off-register lines.

I add several windows to the shack with simple flat brushstrokes, lightly lifting out some of the paint with touches of a paper towel, and add a raw umber shutter to the cabin window. A few curved lines are edge-stamped over the net, and additional edge stampings appear in the boat cabin, mast, ropes, boat railings, and several other places. Switching to a no. 8 round sable brush, I paint the headlight above the cabin, birds, and other details. Finally, I place a few intense spots of Winsor red under the headlamp, on the lower right face of the shack, and on the oarlocks for the final touch of icing on the cake.

OTHER EXAMPLES

Arizona Fantasy, *by Bud Shackelford.* The massive curves and sweeps in this mountain-scape, including the small buildings, water tank, and large cactus, are set up by knife scratches. Knife scratches also create the textures in the tall grass and roundish tumble-weed. Sandpaper scratches appear as vertical sweeps from the right hill up into the sky.

The large circular sweep between the two mountains is designed as a socket to nestle the sun, and the straight crisp tops of the hills offset the curves. The painting is a study in curves versus straight lines; in lights against darks and darks against lights; and in combinations of large, medium, and small shapes. The color plan is an analogous one of warm reds, yellows, and umbers, all closely related.

Old Fort, *by Bud Shackelford.* The theme of the painting is a ghostly portrayal of a long-forgotten Civil War battle, with images of soldiers, guns, cannon, and graves. Many shapes and forms are also left to the imagination (a method of involving the viewer). Precut blotters and template lift-offs are used to create the ghost images. A cool color scheme in analogous colors is used. A good example of paper-torture technique, the painting was begun with bluish washes over paper that was severely creased and crushed. Many of the abstract patterns that emerged from the initial wash were utilized to create the space divisions and numerous flat patterns that make up the gigantic foundation of broken concrete slabs and granite boulders from which the fort arises.

CHAPTER SIX

MASKS AND RESISTS

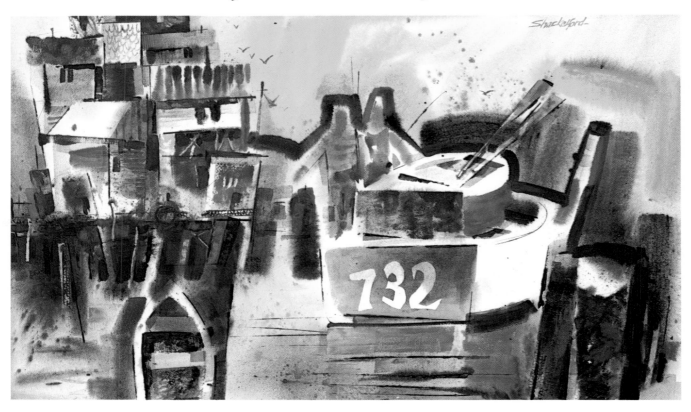

Wharf Enchantment, *by Bud Shackelford*. Three-dimensional forms are combined with flat, two-dimensional shapes in this experimental painting. The two boats on the wharf and the lower left shed are turned to three-quarter views showing fronts, sides, and tops, which make the forms appear solid. The balance of the painting is in flat, two-dimensional patterns, showing either front, side, or top views. Notice the top-view appearance of the wharf (no converging perspective lines) and of the boat in the water.

Flat shapes set up solid forms and make them appear more solid. Showing several points of view in one painting was a form of distortion used by Cézanne, and later by Picasso and Braque. Can you pick out the flat stampings, corrugated stampings, edge stamping, and scrape-offs in this painting?

This chapter will describe masking and resist techniques. Two of them appear here: Frisket paper, which was used to mask the number, and masking tape, which was used to mask the seats of the rowboat in the water.

Masks and resists are used for preserving the whites of the watercolor paper before painting over them and are applied on dry paper only.

One masking device is masking tape or masking paper. Masking tape is used for simple shapes that can be cut out of the tape and pressed into position on the watercolor sheet. For more complex masked shapes, you can use transparent, adhesive-backed Frisket paper or colored Zippatone paper. The paper is removed from the backing sheet and positioned on the paper, and a maneuverable X-Acto knife is used to trace the outline. Then, unwanted portions are peeled off. After use, the masked shapes are peeled off and discarded, exposing the pure white shapes below.

Subtle, feathery shapes are best masked out with thinned rubber cement and Maskoid or Miskit, products similar to rubber cement. These liquid masks are brushed (actually painted) onto the dry watercolor paper. (For permanent artwork, Maskoid and Miskit—products that are intended for artists' use only—are preferable; rubber cement may leave a film on the paper that can yellow it.) When you're through, you can rub it off with a pick-up eraser or with your fingers. Another way to preserve the white paper is by using resists, such as colored or white wax crayons and squares of paraffin. Unlike masks that are removed when no longer needed, resists can remain in place on the finished painting and serve as part of the design. (If you should wish to remove the wax, however, you can iron it off, using brown wrapping paper as a press cloth. The wax will adhere to the wrapping paper.)

MATERIALS AND TOOLS

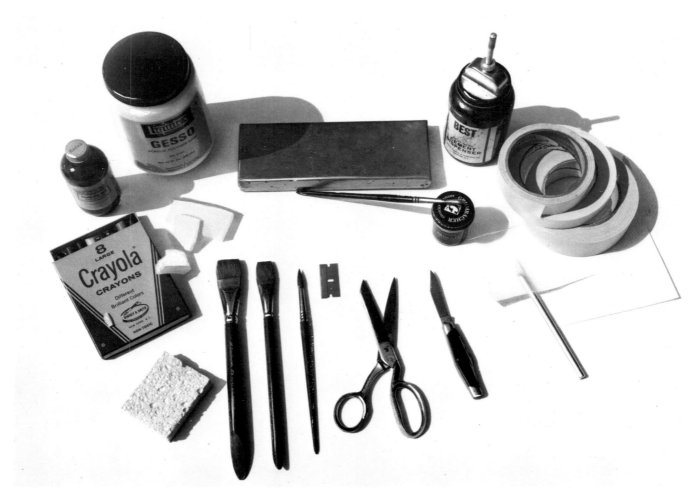

The following supplies should be assembled for this chapter: 1″ and ½″ (25 and 13 mm) flat brushes, a no. 8 pointed round sable brush, a kitchen sponge, your watercolor palette, a single-edged razor blade, scissors, pocketknife, an X-Acto knife, masking tape, Frisket paper, rubber cement, Maskoid or Miskit (with an old no. 6 or 8 pointed brush for their application), crayons, paraffin, gesso, and Kodak Photo-Flo 200 solution. (The last two products are optional; their use is described in the "Tips" section.) Finally, you'll need a plastic bone for pressing the tape down (see "Materials" section in the preceding chapter), which is not shown here.

Scissors are used for cutting simple masking-tape shapes such as flying birds, fences, and rectangular, triangular, and circular shapes. The X-Acto knife is used with Frisket papers (pictured here under the Frisket film) for more complex shapes, and the pocketknife is used for scraping pigment off the wax crayon or paraffin resists, after the painting has dried.

The brush in your rubber-cement jar can be used to apply rubber cement in massive movements, or you can use the old pointed brush for smaller shapes. The pointed brush is also used to apply Maskoid or Miskit in painted shapes. The brush should be washed with hand soap before and after using, as these products are damaging to brushes. As you apply these products, you can even leave the soap in the brush so that less damage may be done to the brush. Further applications will be described in the following exercises.

APPLICATIONS

Masking Tapes. Cut simple shapes out of masking tape, and press them into position on dry paper. The posts and crossbars are all cut separately and overlapped. Use the bone tool and press all edges down securely to avoid any seepage under them. Harder surface papers, such as Strathmore Gemini and Arches, are better for this process. Now mix a dark burnt umber wash and brush it over the area you've masked out. When it's dry, slowly peel off the masking tapes, being careful not to yank off some of the painting surface. The result should be crisp, white images.

Sails Example Using Masking Tapes. Draw the composition, cut masking tapes out with scissors for the sail shapes, wharf, and pilings, and press them into place. Then cut out masking tape shapes for the white tower, sun, flag, striped piling, and boat hull, and press down securely with the bone. Select one color for the entire exercise and hold it to three values: light, medium, and dark.

With a moist sponge, wet the surface of the paper. With your 1″ (25 mm) flat brush, apply a light wash over the entire area. (Brush all washes over the tapes.) Next mix a medium tone and brush in the clouds, sea, and building, adding a slightly darker roof. Surround the building with darks and add the little building with the gable roof. Paint the waves in flat *U*-shaped strokes with the no. 8 pointed brush. Let everything dry thoroughly, then carefully peel off all the masked shapes to expose crisp white patterns. With light blended washes, add form to the two sails on the right and to the tall piling and boat hull. Use a flat tone on the sail and jib sail on the left and on the sun. Add a little shadow to one side of the wharf pilings. Finally, with the pointed sable brush, add the tower roof, windows, shutters, piling stripes, dark sailboat hull, sail numbers, and other details.

Masking with Frisket. For more sophisticated shapes, you can use transparent Frisket paper, which is like an adhesive film. Draw the shapes with pencil first on the dry watercolor sheet; then, lay the Frisket paper over the entire area. At this point, don't press it down too hard. Trace over your lines with an X-Acto knife, cutting through the Frisket sheet only, and peel off the unwanted portions. Now, using the bone, press down the remaining Frisket hard enough to prevent seepage from crawling underneath. Wet the area with a damp sponge and wash in a medium burnt-umber tone over everything, using your 1″ (25 mm) flat brush. When the paint is completely dry, peel off all the Frisket to expose the crisp white patterns.

Creating a Mission Graveyard with Frisket Papers. First, draw the composition in pencil on the dry paper, press a sheet of Frisket paper over it and trace the parts to be masked, then cut them out. These masked areas include: the grave markers, the tree trunks and branches, the fence, rocks, sun, and the mission bell opening. Peel off the unwanted Frisket, and press down hard on all the remaining masks. Now wet the entire area with a moist sponge and add a light wash of burnt umber all over. Follow with a darker wash under the sun and over the Frisket trees covering the portions shown; this wash should blend into the first wash. Continue the wash into some of the foreground, painting right over the masked parts.

When the paper is dry enough to hold crisper edges, paint the mission building. The left side of the building is textured with a flat mat-board stamping. A deeper shadow is painted to the right of the mission, right over the masked tree trunk and grave markers. The mission doorway is added, along with other dark tones near the left-hand marker and in the shadows behind the stones and under the fence. When the paper is completely dry, peel off the Frisket masks, exposing all the crisp white patterns. Then complete the tones and details.

Masking with Maskoid and Rubber Cement.
Maskoid (or Miskit) is painted on dry paper with a pointed brush. It contains a light pink dye that makes it visible when it's applied; and it's excellent for masking for animals, birds, figures, and other more subtle and intricate shapes. On the left, try painting a pelican with Maskoid, along with a few strokes of grass. Then on the right, using the container brush found in most rubber cement bottles, apply some swirls of rubber cement, letting it trail off to thin threads, such as on the shapes on the right. Cover both areas with a medium tone of burnt umber. When it's dry, rub off the Maskoid and rubber cement, exposing the pure white patterns. You can use your finger or a "pick-up" eraser to remove them.

Barnyard Scene with Maskoid and Rubber Cement Masking. First, brush large swirls of grass in upward strokes with rubber cement on the applicator brush. It should take about seven strokes. Next, with Maskoid solution, paint on the finer shapes for the horse, the two shed posts, and the white space for the louvered window and fence. Since these products dry quickly, you can start applying washes immediately. Develop the painting as shown above. When all the major shapes and values are complete, rub off the Maskoid and rubber cement, exposing the pure white patterns. Now tone the grass effects, and model the horse slightly. Also tone down the post behind the horse. Finally, add the edge stampings and finishing details, such as the spots in the hills and grass, the wheel, and the birds.

Paraffin and Crayon Resist. Waxy surfaces will resist watercolor pigment, especially the dye-type colors (such as phthalo blue, alizarin crimson, and phthalo and viridian green). For this exercise, simply draw shapes on dry watercolor paper with paraffin or light-colored crayons. Then wash a flat tone of any color over the markings. If you use a dye color, the light markings will appear instantly. If you use a more opaque color (such as burnt umber or any of the cadmiums), the markings will appear, but not as definitely. Where the paint is dry, lightly scratch the surface of the waxy markings with a pocketknife and the pigment will disappear, exposing the white paraffin or crayon below.

Seascape with Paraffin Resists. For this example, use a small square piece of paraffin to draw the rocks, fence, sails, stripes, reflection in the water, and the round sun. Wet the paper with a moist sponge and cover the entire painting area with a wash of light phthalo blue. Mix the same blue with burnt sienna and paint in the mountain and beach. Notice that the resist areas always appear instantly. When the paint has dried somewhat, paint in the darker sail with one of the blues. The stripes will appear instantly. Finish the sails with a few edge stampings and paint all other details with your no. 8 pointed round sable brush. The paraffin will remain as part of the painting.

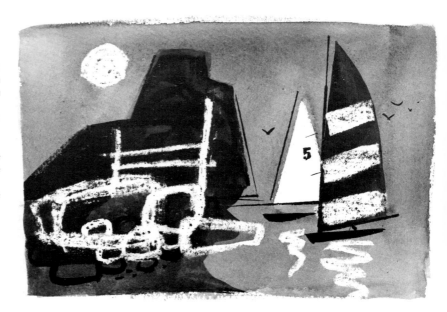

TIPS

1. Masking tapes must be pressed down hard on the edges, especially when used on rough-surfaced watercolor papers. This will prevent seepage underneath.

2. Lift masking tapes from the smallest tips or corners inward to avoid pulling up any of the painting surface. Pull slowly.

3. Frisket papers are expensive, so save all leftover pieces. To save, press them down again on their backing sheets.

4. Don't use Maskoid, Miskit, or rubber cement on soft-surface papers such as Aquarius or Aquarius II because, in removing them, you will lift up some of the paper, too. Choose another kind of paper when you plan to use resists.

5. To paint over an area containing paraffin or crayon, first scrape off the excess wax. Then mix your pigment with a wetting agent designed to stick to slick surfaces, such as Kodak Photo-Flo 200. (Follow the directions on the bottle.) You can mix hand soap containing glycerin into the pigment instead, for a similar result.

6. If you first paint the watercolor sheet with diluted acrylic white gesso (one part gesso to four parts water), let it dry, then paint over it with watercolor, you can get interesting, subtle resist effects. Glazing is particularly effective on the portions of the paper treated with gesso. (See the painting *Red Sun* at the end of this chapter.)

PROJECTS

1. Create a composition with a windmill, sheds, and trees. Include simple related props that you can mask out with masking tape and Frisket paper, such as fences, tree trunks, branches, supporting beams and cross members for the windmill, a ladder, rocks on the ground, and chickens. Use a limited warm color scheme of three or four colors and paint the subject following the guidelines in this chapter. Then lift the tapes and complete the painting.

2. Without any drawing in pencil, develop an ocean with massive waves, using rubber cement applied with the applicator brush. Use rubber cement thinner if the cement is too thick, so that sweeping streaks appear in the brushstrokes. In the foreground, use long, sweeping strokes in concave curves, varying the lengths and depths of these curves. Add choppy, smaller waves in the middle distance. Next, close to the horizon create several small, leaning sailboats with the tilted masts and full sails blowing in the wind. Paint these shapes with Maskoid.

Now you can paint a bluish sky with a wet wash of ultramarine blue and a touch of burnt sienna to neutralize it, from the top right on down past the sails. Darken this same blue in the sailboat area and blend it back up into the sky, letting it lighten on the way up. Next, mix a rich green of viridian neutralized with burnt sienna, and continue from the horizon right down over the rubber cement. Darken the value of this color as you progress downward. Let it all dry, and rub off the rubber cement and Maskoid. Crisp white sailboat shapes should appear in good contrast to the darker blue in that area, and waves should appear in crisp, white, brushy-looking curves.

Finally, add tints or darker values to enrich the movements and shapes of the waves. Also add a slightly modeled tone to the sails to fill them with wind and a touch of darks to the hulls—just enough to suggest that they're sailboats.

3. Plan a composition with a simple side view of a fishing shack on a wharf. In several areas, rub red, yellow, and brown crayons on the wall of the shack in vertical strokes. Bear down hard for rich, waxy color. Then switch to paraffin to draw the pilings and a row of tires hanging along the side of the wharf. Next to the shack, hang up some nets, also drawing the sagging net areas with paraffin. Bear down on the paraffin to cover all these parts with heavy wax.

Now paint the subject with your choice of colors. Use new gamboge over the crayons on the shack, and a dark, cool color over the pilings to create the negative spaces. If you use dye colors (such as alizarin crimson, Winsor red, or phthalo blue) which behave like colored inks, the resist patterns will instantly appear.

DEMONSTRATION

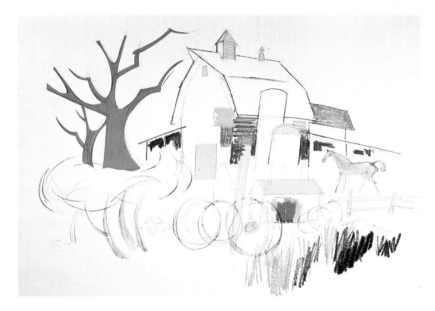

Step 1. I draw this painting in pencil and cover the simplest shapes with masking tape: the barn door and window, roof steeple and vent, silo top, shed roof, post, and fence, pressing the tape down firmly. Then I strip a sheet of colored Zippatone film from its backing (I could also use colorless Frisket film, but the Zippatone shows up better here) and lightly press it down over the trees and branches on the left. I cut over the pencil lines with the X-Acto knife, strip off the unwanted pieces, and then press it down hard with the plastic bone. Next I apply rubber cement with the applicator brush in swirling curved strokes for the shrubbery below the large trees. Then, soaping an old pointed brush to protect it, I paint the small horse, wheels, discs, and trunks of the shrubs with Maskoid. (The light beige dye in it makes it visible.) Now I apply the resists. Pressing down hard, I rub warm-colored crayons on the sides of the barn and shed and in the grass, and apply cool colors in the negative openings under the lean-tos. Then I draw in the foreground rocks and tree trunks with the corner of a square piece of paraffin. I also add a few boards on the front of the barn. Like the rubber cement, the paraffin is colorless and only appears after a wash is applied over it.

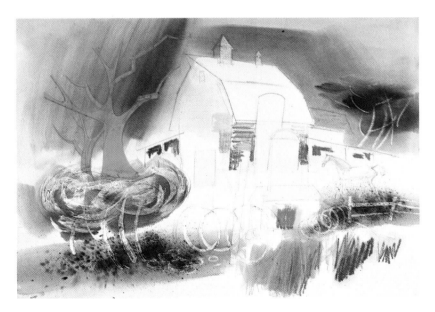

Step 2. The entire sheet except for the barn is moistened with a damp sponge, and light washes of burnt umber are applied to the sky with the 1½″ (4 cm) flat brush over the trees, roof and barn wall. I also work it over the crayon grass area, the fence area, and the foreground shrubs and ground. Now darkening the umber with thicker, richer color, I add accents to the sky and the dark tree foliage (note that the paraffin trunks and branches appear instantly) and place some darker tones in the grass. With a toothbrush, I splatter some texture over the fence and discs with dark umber. Adding some ultramarine blue to neutralize the umber, I paint around the shrub foliage in swirls and add the foreground tone. (Notice that the paraffin rocks appear suddenly.) Toothbrush splatter is added to the foreground area while it is still moist.

Step 3. With all the masks still in place, I continue painting the surface of the barn and sheds with new gamboge on the sunlit sides and combinations of burnt umber and scarlet (alizarin crimson with ultramarine blue) on the shadow sides. The crayon colors resist the watercolors and pop right out. Note that the white board textures appear on the sunny side of the barn. I now add dark tones (ultramarine blue neutralized with burnt umber) in the open lean-to areas, working right over the horse. This time, I leave the posts white by simply skipping over them while painting the negative shapes. (Notice that the blue crayon pops right up as it resists the watercolor.) Next I wet the sides of the barn and blend new gamboge and raw umber washes to suggest cylindrical forms. I also complete the roofs and shadows.

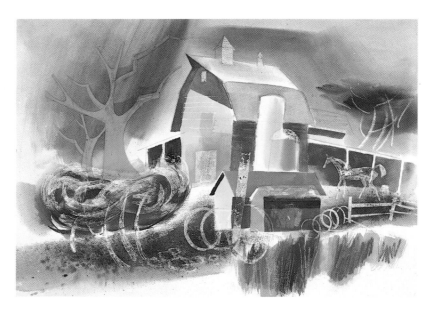

Step 4. Now for the surprise! When everything is completely dry, I carefully lift up the masking tape and Friskets and rub or lift off the rubber cement and Maskoid shapes with a pick-up eraser to expose all the white, crisp shapes and patterns. Their appearance is stark and contrasts strongly with the dark painted areas. To alleviate some of this contrast, I add tones to some of the crisp whites. I also add gray shadow tones to the large trees and the post, place warm grays in the swirling shrubbery, paint new-gamboge tones over the wheels and discs, and add dark details to the steeple. Finally, I draw a simple figure in the doorway of the barn with pencil and place a piece of Zippatone over the drawing to mask it. This is the second time I've masked this area, using different materials each time.

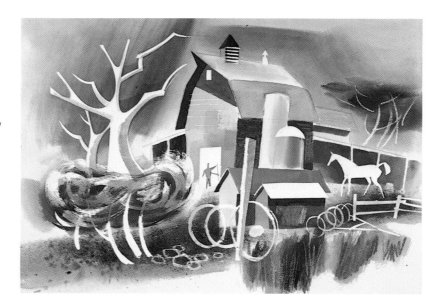

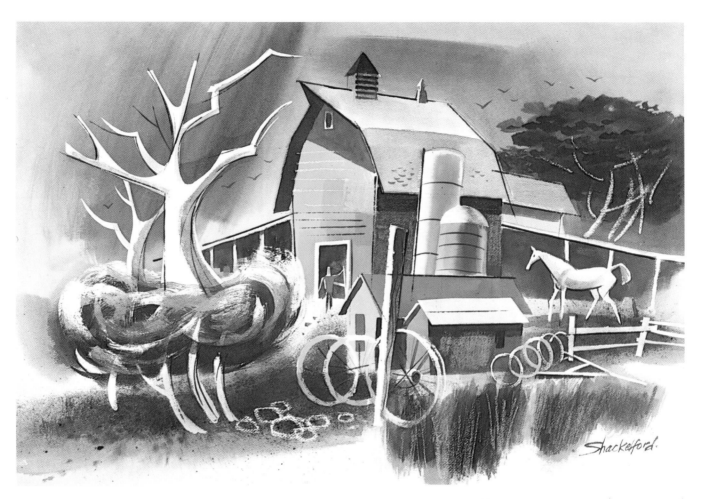

White Stallion. Now I paint the doorway in a medium gray. I work right over the masked figure leaving a white edge around the doorway, and darken the shadow in the upper left. I also add a dark center to the small window above. Remoistening the tree foliage on the right with the no. 8 pointed round brush, I complete the suggestion of foliage and textures in dark warm grays and add light gray tones to the horse. Then I work on the details, adding the horse's eye, birds, roof textures, lines around the silos, wheel spokes, and other fine points. I also tone in the steeple and vent shadow. Next, using a strip of mat board, I add off-register edge stampings to the barn and sheds. I also add a few dark boards to the sunny side of the barn and apply curved-edge stampings to the tree trunks and branches. Finally, I carefully peel off the Zippatone paper from the figure in the doorway and make it stand out with Winsor red. Then I add flesh tones and brown jeans, and I'm finished.

OTHER EXAMPLES

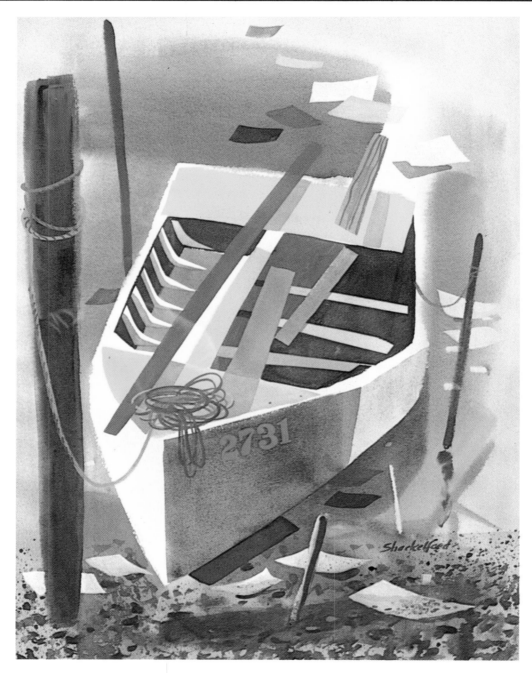

Rowboat, *by Bud Shackelford*. There were two masking stages in the development of this painting. First the object was masked out as a large shape, then the mask was removed and separate pieces within it were again masked out while other areas around it were worked on. Thus, in the first stage, the subject was drawn in pencil and masked out with Frisket paper (masking tape was used for the simpler shapes of the papers). Then the entire sheet was moistened with a wet sponge, and the land and water areas were washed in with a large flat brush and textured with a pointed sable. Two stakes were scratched out with a wooden matchstick (a shadow was added to one), and three pilings were painted in. Then,

when the paper dried, the masks were lifted up. At this point, the small papers in the foreground were toned slightly and sand texture was added to some of them. When the paper was again dry, the second stage was begun. This time only the ribs and planks inside the boat were masked with Frisket paper; the interior portion of the boat was painted right over it. When it dried, the Frisket paper was removed, the planks and ribs were toned and shaded, and the yellow boat-deck patterns painted. The side of the boat and the final details were painted last, including the number on the boat, the rope, a few darker papers, and the dark accent under the boat.

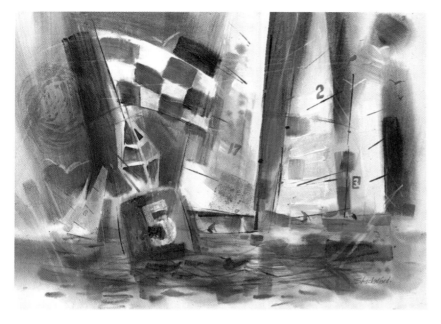

Pylon 5, *by Bud Shackelford*. Before the actual painting could begin, the surface had to be prepared with crayon and white gesso resists. Gesso was applied to the white areas in horizontal and vertical strokes on the sails, flag, and buoy. Then, a white crayon was used to draw the birds and to mark the surface of the paper in diagonal and horizontal strokes. Yellow crayon were rubbed vigorously in and around the sun and below one of the sails. Red crayon was rubbed on the boat hull and orange crayon into the buoy; and light blue and purple crayons marked the reflections in the water. Finally, the entire surface was moistened with a sponge, and the painting proceeded in the usual manner.

Note that wherever pigment goes over a crayon resist area, the resist pops out; but when light-colored glazes are applied to the gessoed portions, a little of the color tone remains. If you have trouble making pigment adhere to a resist area, mix diluted Photo Flo solution into your paint mixture on the palette. Photo Flo was used here on the tiny red figure placed over the yellow crayon and in that extra touch of Winsor red on the boat hull.

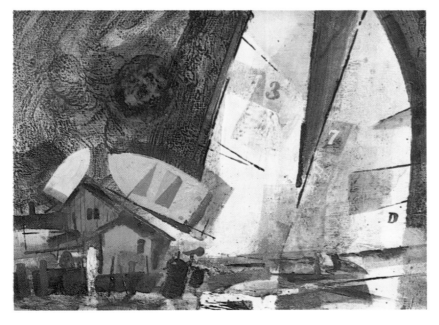

Red Sun, *by Bud Shackelford*. The entire surface of this painting was first coated with white gesso, and a brownish red crayon was rubbed into and around the sun. Then the entire surface was wet and light washes of alizarin crimson and new gamboge, mixed with Photo Flo solution to make it adhere, were applied over the sky areas. Additional red was washed over the sun and allowed to dry completely. The mottled texture effect on the sky was accomplished by rubbing a wet, flat, soft-haired brush into hand soap, then dipping it into ivory black pigment and sloshing it around the surface. The tones in the sails are washes of Payne's gray, partially resisted by the gesso. The control of the other pigments throughout the painting depends on the ratio of plain water to the amount of Photo Flo solution added. The less solution used, the stronger the resist will be. The more opaque colors (such as cerulean blue, cadmium orange, and cadmium yellow) were also mixed with a touch of Photo Flo for the boat shapes and shacks.

CHAPTER SEVEN
SPLATTER AND SPARKLE

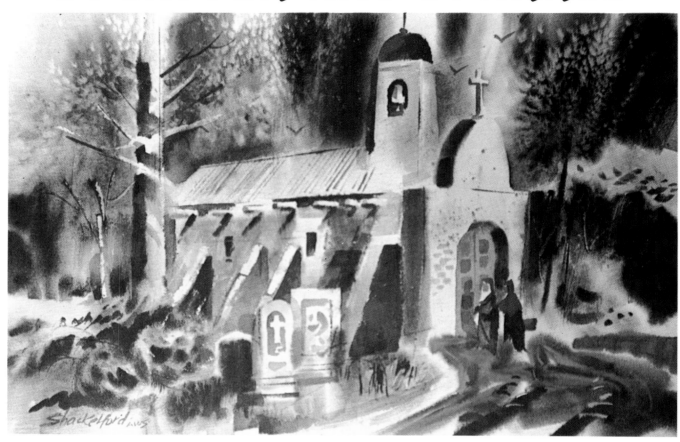

Sanctuary, *by Bud Shackelford.* This little mission-type church started as a juicy wet-into-wet painting with a variety of complementary violets, yellows, ochres, and siennas, and touches of greens and reds. The sparkles in the sky were created with ordinary table salt sprinkled onto the surface soon after the first color washes were applied. The salt absorbed the pigment, leaving light crystalline spots that suggest foliage or stars. Also, for mortar, a little splatter was flicked onto the face of the church from a toothbrush.

(Splatter and salt effects will be described in this chapter.) The translucent feeling of this painting is offset with a few thick opaque pigments such as the rich cadmium oranges in the dirt road, and the cobalt blues in the triangular buttress, the dome on the steeple, and the hood on the nun. The painting is three-dimensional, giving the feeling of solid forms in perspective; however, the colors are inventive and more colorful than those normally seen on an actual whitewashed adobe mission.

Splattering pigments by various methods can create textures for a wide range of effects, from gravel to foliage. Splattered pigment can be applied in varying degrees that range from spray effects almost like airbrush to coarser effects like sand. It also can be dropped off brushes or slung across the paper for long streaks.

Exciting crystalline-textured happenings can also occur when table salts and rock salts are dropped into wet pigment areas. They create impressions of snow, stars, and other sparkly effects. Watermarks and alcohol drops create additional useful effects.

These experimental techniques can be as surprising to the artist as to the viewer, because they never turn out the same way twice! Each happening is a new creative experience. You'll find that dye colors react differently from earth colors and that the wetness of the paper and richness of the pigment also make a difference. Even different paper surfaces affect the results. You'll find the exercises in this chapter both surprising and challenging.

MATERIALS AND TOOLS

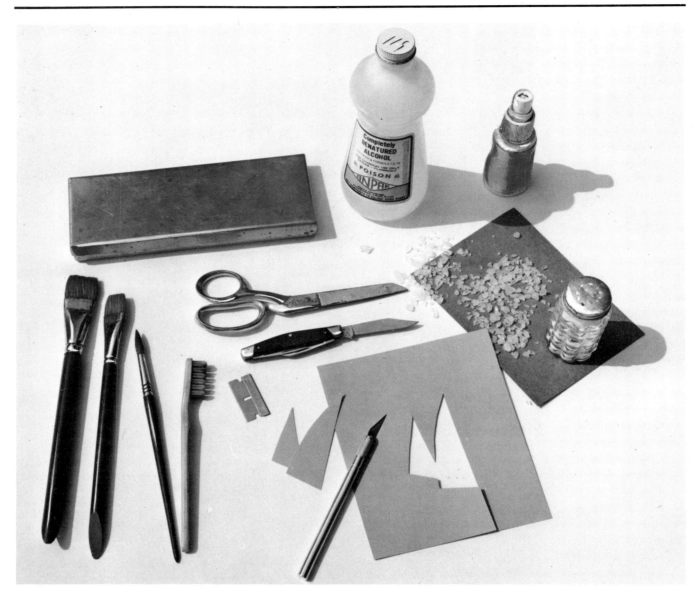

For the exercises in this chapter, you'll need 1″ and ¾″ (25 and 19 mm) flat brushes, a no. 8 pointed round sable brush, an old toothbrush, your watercolor palette, scissors, pocketknife, single-edged razor blade, tag board, X-Acto knife, table salt, rock salt, denatured alcohol, and an atomizer with clear water. Several types of papers can be used, as you will see in the following exercises.

The flat brushes are used to splatter spots or streaks of textures. The toothbrush is used to splatter more accurately positioned dots; by dragging your thumb over the bristles, you can direct fine dot sprays to specific areas. These sprays also can be used with tag-board template patterns that are cut out with scissors, razor blade, or X-Acto knife. Special uses for salts, alcohol, and the atomizer spray are also explained in this chapter.

APPLICATIONS

Brush Splatter. Splatters can be practiced with 1″ and ¾″ (25 and 19 mm) flat brushes on 140-lb Arches cold-press paper. Mix a wash of burnt umber with your brush and flick it sharply downward, stopping your strokes a couple of inches short of the paper. A series of spots should hit the paper, splattering slightly. You can also sling the splatter at an angle to create a string of spots or streaks. Try doing fused splatter in moist areas and crisp splatter in dry areas.

Toothbrush Splatter. Pigment can be slung off a toothbrush in the same manner. Dip a moistened toothbrush into burnt umber, mix it with water on your palette, working it evenly into the bristles, and flick it at the paper. Notice that the dots can be positioned more accurately because the bristles are held perpendicular to the paper. By dragging your thumb over the bristles, you can create a fine spray that you can direct to a particular area. Hold the toothbrush sideways during this application.

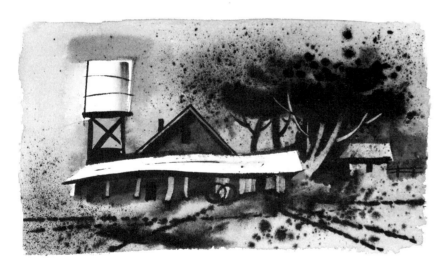

Using Brush and Toothbrush Splatter in a Farm Scene. Draw in the subject first with pencil. Then, with a moist sponge, dampen the sheet (working around the long white roof and water tank). Using your 1″ (25 mm) flat brush, apply a light wash of burnt umber over the entire sheet, except for the roof and tank. Darken the sky over the tank and the lower left foreground. Scrape out the farmhouse with a cut mat-board edge while the pigment is still moist. Quickly mix a richer wash of burnt umber (not too wet), and apply the main foliage forms in broad U-shaped strokes that will fuse into the moist area. Darken the areas below the foliage and around the small shed. Scrape out some tree trunks with the tapered Aquarelle brush handle. Now, holding up a piece of tag board to block the areas you don't want to hit, sling some toothbrush splatter into the foliage to suggest foliage textures, and spray toothbrush splatter to the left of the foliage. Then, with either flat brush, flick textures into the foreground and sling diagonal streaks off the brush as shown. (Again, protect the subject portion with the tag-board shield.) You may have to rewet areas with the sponge where you would like fused splatters. Finally, complete the details of the door, windows, roof and roof shadows, fence, and water-tank scaffolding.

Toothbrush Splatter with Templates. Cut a pattern shape out of a tag-board template with your scissors, razor blade, or X-Acto knife. Save both parts. Mix some burnt umber on the palette with your toothbrush and practice a fine splatter on a test sheet first. Use the thumb-dragging method. Now hold the template part with the opening flat on the sheet and direct a fine spray over the opening. Lift the template. You should have an impression similar to the left pattern.

Now take the cutout and position it on the right. Make sure there are no bows or bends in it. Spray over it with the toothbrush thumb-dragging method again, and lift the template up. This time the template has masked out the pattern, giving you the reversed impression.

Using Templates and Splatter for a Country Theme. Start with a light burnt-umber wash applied over the entire sheet, reserving some light areas in the barn. Paint the hill, tree foliage, and grass in darker colors while the sheet is still moist. Now mix some darker umber with your toothbrush and cover the top edge of the shed roof with a 4″ × 6″ (10 × 15 cm) filing card (or tag board). Spray a tone over the card into the sky. A crisp light edge will remain. Change the card position to the back sloping edges of the roof and spray over the card into the tree area. Next, cut a circle out of tag board, position it for the windmill, and spray over it into the sky. Then lift off the circle, exposing the circle impression.

Now cut out a tag-board template for the fence posts and cross members and place it in position. Spray over it and remove. Cut out a template walk in perspective, position it, and spray over the open portion of the template. Lift it to expose the darker walk. Finally, finish the barn, windmill, tree trunk, and branches as shown.

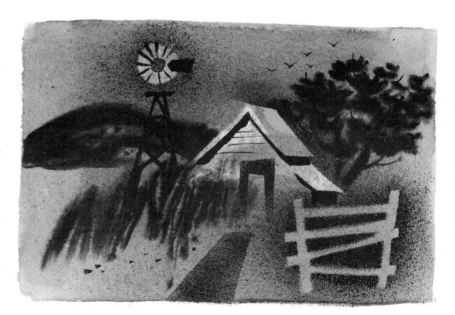

Salt Sparkle. Ordinary table salt is used to produce the light crystalline textures in this exercise. The paper here is Strathmore Gemini cold press, but Strathmore Aquarius II works equally well. Wet the paper first, then apply a medium-value wash of phthalo blue (or any other dye color). Sprinkle the salt on while the pigment is still wet. During the drying, sprinkle on a little more salt. The smaller spots are from the second application. Salt slowly absorbs the pigment from the paper; it takes up to a half hour for results.

Rock Salt. Drop a handful of rock salt into a cloth rag, fold the rag over the salt, and hammer it several times to produce various-sized granules. Using Gemini rough paper this time, wet the paper thoroughly and apply a medium-dark wash of phthalo blue on the surface. Sprinkle the crushed chunks and larger salt crystals in several areas, and throw some of the finer powder into other areas. Leave it alone for about a half hour, and the results will be surprising. Something different happens each time.

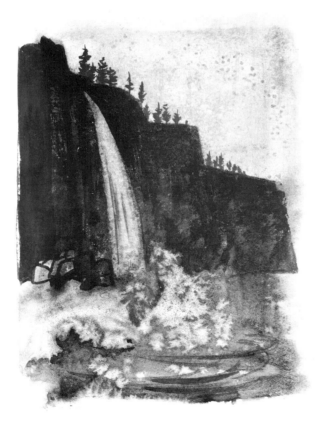

Developing a Scene from Salt Activity. Try several example sheets of salts sprinkled into either a sky area or foreground area and set them aside to dry. Then select the most exciting salt reaction, and develop a subject that takes advantage of these salt effects.

In this example, I visualized a waterfall over a tall cliff, causing a parting of the spray created by the salt effects. Of course, the salt textures had already been created, and it was only a simple matter of painting the dark cliff and wiping out the waterfall using precut templates and a moist sponge. Then, with the no. 8 pointed brush, I added trees, rocks, and oval water ripples. It had a moonlit look, so I also added a round moon by wiping it out over a round template.

Watermarks. These effects are created by wetting the paper and applying a burnt-umber medium-value wash over the surface. Before it's dry, saturate a thick brush with clear water and touch some puddles of water to the surface in several places. Let these spread out and wait a few minutes. Dry out the lightened marks with a tissue and repeat the process until you're satisfied with the result. Occasionally, thin dark edges may surround the watermark.

Alcohol Drops. Mix a large, dark wash of umber, and brush it onto a sheet of cold-press or plate-finish (hot-press) watercolor paper. Immediately drop a number of denatured alcohol spots over the sheet. If timed properly, they'll circle out as shown with center impressions, crisp inner circles, and fuzzy outer edges. I find that I get better results on slicker surfaces. Also, try dipping a pipe cleaner into alcohol and touching it to the surface of the paper for larger circles.

Using Watermarks and Alcohol Drops for Clouds and Mountains. Work quickly on this one, as timing is important. First, mask the two sails with masking tape. Moisten a sheet of cold-press watercolor paper and apply a medium-value umber wash in the overall shape of the cloud pattern with the ¾″ (19 mm) flat brush. Paint the dark mountain up to the clouds and immediately drop alcohol spots in the foothills. Paint the top of the mountain down to the clouds. The clouds should still be slightly moist and ready for the waterdrops. Puddle these in with the no. 8 brush, pushing the puddles around and moving the collected pigment into neighboring puddles. Dry the brush slightly and loosen more pigment in the light areas. Dry the light centers with wads of tissue. Repeat in several areas until the results look interesting. Now peel off the masking tape and tone the two sails. Add the hulls, a few tiny palm trees, and sweeps of waves with the round brush, switching to the flat brush for the waves.

TIPS

1. Brush splatter takes practice to perfect. Practice it with various brushes in wet, moist, and dry areas. Some artists flick drops off the brush by knocking it against the index finger of their other hand.

2. Toothbrush spray should always be tested on a practice sheet before spraying on templates. Too much water or pigment in the brush could produce unwanted splotches.

3. Make sure your tag-board templates lie absolutely flat before you spray. You can hold a small template in place with a toothpick while spraying.

4. Earth colors (umbers and ochres) are less desirable for salt effects. Use dye colors.

5. Timing is important with salt. If the paper is too wet, the salt may just dissolve. If it's too dry, the salt won't absorb enough pigment for the crystalline spots.

6. Alcohol isn't effective on some papers. Test it on the back or on a scrap sheet.

PROJECTS

1. This will be a brush and toothbrush splatter project. Pencil in a barn scene similar to the "Country Theme" example using templates and splatter shown earlier in the chapter, only move all the parts around. Cut out a fence template in a longer, thinner horizontal pattern and move it to the left-hand side of the composition. Let it overlap the left portion of the barn. Move the grass to the right side, and this time use curved strokes for movement. Make any other changes you wish, including a different style of barn. Now, using limited colors of your choice, develop the scene using all the splatter and fine splatter techniques described in the "Country Theme" example.

2. Have table salt and crushed rock salt on hand for this project. Plan a snowy winter scene that includes using table salt in a large sky that will occupy two-thirds of the composition. Include a row of evergreen trees and a small cabin near the horizon, and light, soft snow masses in the foreground. Use only cool colors.

First, moisten the paper on both sides. Starting with the large sky, wash in a medium tone of ultramarine blue, neutralized slightly with burnt umber. Sprinkle table salt over the sky, as in the example shown previously. Next, rewet the lower portion, and with the 1½″ (4 cm) flat brush, tone in a snow-covered foreground. Use broad, convex-curved strokes of phthalo blue neutralized with a tone of burnt umber. Darken the left side of these fused tones with a purplish mixture of alizarin crimson and ultramarine blue to suggest the rolling snow-covered field. Immediately sprinkle on various-sized rock salt granules in just a few select areas. You may prepare one or two more of these underpaintings and select the best result. Put them aside for a half hour or until the salt effects have matured, then select one and paint in the trees and cabin to suit your own creative tastes.

3. Try your own version of a pond covered with floating lily pads and a background of marsh grass. Leave room for a sky with a long cloud above.

Wet the paper and wash in a dark-green foreground of water (use phthalo green or viridian neutralized with a little burnt sienna). Immediately, using a pipe cleaner dipped into denatured alcohol, create numerous circles of lily pads by touching the alcohol to the wet pigment many times. Overlap some and let others float free. Next wash in a light, flat, cobalt-blue sky. Using the no. 8 pointed brush and yellow ochre and burnt umber, brush in the tall marsh grass in vertical strokes applied along the upper edge of the water. This edge should curve slightly around the pond. Finally, develop a cloud in the sky using the watermark process shown in the "Clouds and Mountains" example.

DEMONSTRATION

Step 1. I use this quick sketch for composing this painting, but I create it with brush and paint, without any preliminary penciling. This painting is planned to make the most of salt sparkle effects in a dominant sky, alcohol and water drop effects in a massive ocean, and toothbrush splatter applications. I select Strathmore Aquarius-II paper, which is excellent for these techniques.

Step 2. Moistening the paper on both sides, I create a free-form sky (within the borders of the paper). Phthalo blue with a touch of raw umber is applied with the 1½″ (4 cm) flat brush for the first wash, with triangular white areas reserved for the sails and buoy. Next, mixing a drier rich, dark value of ultramarine and burnt umber, I paint the darker negative passages between the sails and create crisper edges flush to the sails. I let the dark color blend into the first wash in the sky areas. Now, I immediately sprinkle on both table salt in the central portions and crushed rock salt around the outer areas. Once salt is sprinkled into an area, it must be left untouched until the area is dry and results are complete before the leftover salt can be brushed off. Full results take about a half hour. While the paper is still moist, I sling some dark toothbrush splatter into the lower right sky and toothbrush spray (dragging thumb over pigmented toothbrush) to the left of the buoy. A few edge stampings suggest the buoy and sail masts.

Step 3. Remoistening only the lower portion of the paper, I brush in the ocean waves. These waves are created with 1″ (25 mm) flat brushstrokes of phthalo green, Hookers green, and phthalo blue, with burnt sienna to neutralize it. I remoisten the lower portion and brush these waves in first. Then, using a pipe cleaner dipped in denatured alcohol, I immediately touch a number of alcohol drops onto the surface many times. Odd shapes are created as some of these drops form puddles. Other drops are overlapped. Interesting circles appear instantly each time. I also create watermarks by dropping pure water into several areas to loosen the pigment, then lifting it off with tissues. I again apply water to these areas; in 10 to 15 minutes it should spread out the watermarks and make interesting edges. In the drier area above, I complete the ocean waves with crisp brushstrokes with a ¾″ (19 mm) flat brush and Hookers green neutralized with burnt umber.

Step 4. Now I concentrate on the subject. I complete the buoy with cadmium yellows light and deep and with cobalt and phthalo blues used in the cage openings. I also add a few more edge stampings and the black flag. Then remoistening the leading sail, I apply a blue gray fused tone with the 1″ (25 mm) flat brush. I cut two number 3's out of tag-board templates, using one for the buoy and one for the flag. I place the large 3 on the yellow buoy and spray a rich Winsor red over it with the thumb-and-toothbrush method. Then I spray the smaller 3 on the black flag with lemon yellow, a more opaque color. Now I cut a tag-board template to shape the lower portion of the lead sail and mask out the sail. With toothbrush splatter (thumb method), I spray a dark gray mist around the mask. I then lift the template, and the sail shape is complete. The tonal impression pushes the other two sails back (a push-pull theory at work). With a few edge stampings I add booms and battens to the sails.

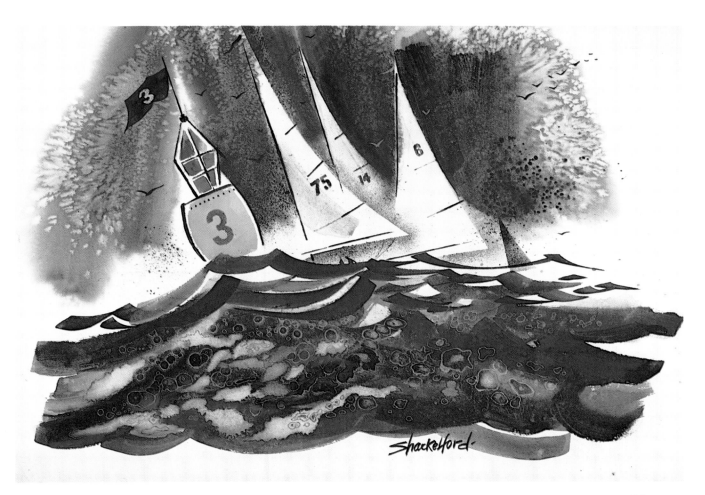

Sea and Sky. I cut out one more template to the triangular shape of the small sail and place it in position. Mixing a purple of alizarin crimson and ultramarine blue with a toothbrush, I spray over the triangular opening. When I lift the template, the pattern is complete. Finally I add numbers to the sails, a couple of figures to suggest that the boat hull is below the forward wave, a few birds and flags, the rivets across the top of the buoy, and I'm done.

OTHER EXAMPLES

Desert Mission, *by Bud Shackelford.* This painting is set up with knife scratches that divide spaces vertically and horizontally and suggest some of the major shapes and forms. It's also painted with numerous color, pattern, and texture variations. Since the painting is flat with a two-dimensional pattern, surface qualities are more important. Lines and edge stampings are placed to allow open passages, and fused tones allow other passages, so that the eye moves easily over the surface. Along with numerous other textures, splatter is also used successfully here to add texture to the hill and sky. It's also loosely slung off a flat brush on the face of the buildings to suggest mortar, or applied in streaks in the cobblestone area and left foreground.

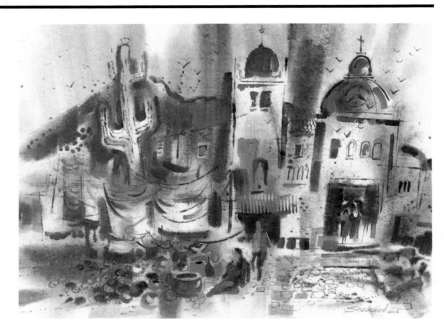

Wharf Sparkle, *by Bud Shackelford.* Interesting salt happenings give this painting its title. Soon after the phthalo blue sky was washed in, table salt and crushed rock salt were sprinkled and dropped onto the area. Also, a few small drops of denatured alcohol created the circle textures in the lower sky areas. The remainder of this painting was developed by using most of the experimental techniques shown in previous chapters.

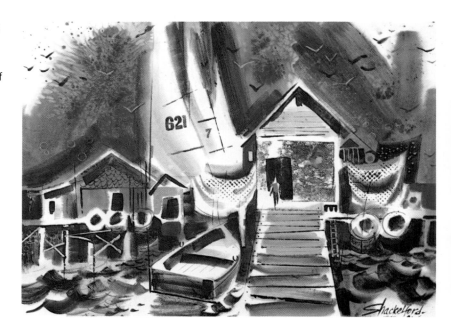

Amaryllis, *by Charlotte Britton. Collection Mr. and Mrs. Sebastian Cassarino.* An excellent example of well-designed negative and positive patterns, this painting is textured with scattered brush and toothbrush splatter. Notice the beautiful variations of hard- and soft-edge control and the change of pace as the fence moves along, with its varied colors, tones, and spacings. The flowers are handled with similar variations, with some shapes left to the imagination. This painting has a warm analogous color scheme of ochres, pinks, and violets.

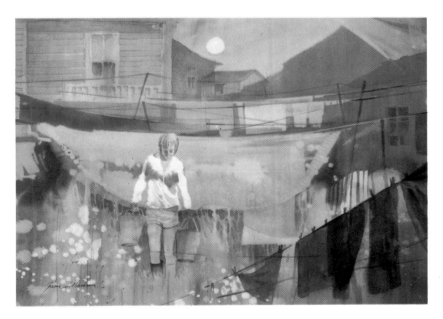

Chores, *by Jason Williamson.* This painting shows several excellent uses of watermarks. In the underpainting stages, the artist dropped water on the surface with a brush before the pigment was dry; then, he placed the entire sheet under water to wash out the white watermarks. This can be seen in the left and center foreground. Other watermarks in the boat and left foreground were tinted with diluted raw sienna after the marks were completely dry.

CHAPTER EIGHT

PUTTING IT ALL TOGETHER

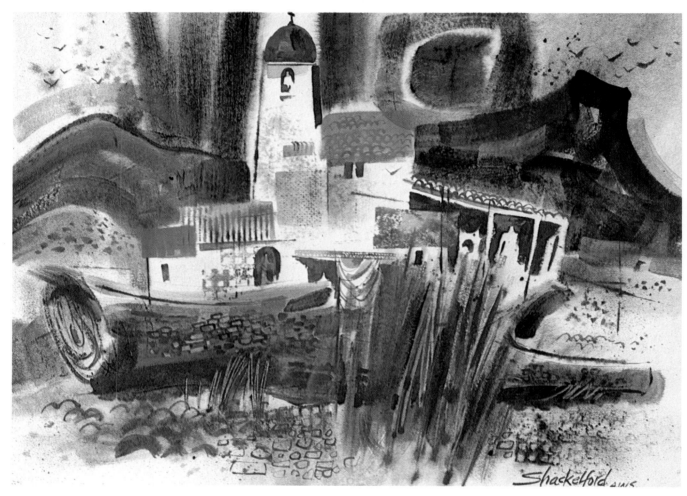

Blue Sun Mission, *by Bud Shackelford*. This painting illustrates the excitement created by brushing various rich pigments into moist white paper. The surprise effect of the translucent blue sun suggests the title of this work. Vertical brushstrokes in the sky and grass counter the bold horizontal shape of the log in the foreground. Other contrasts are evident: the flatness of the mission buildings compared to the three-dimensional solidity of the log, and the angular shapes of the buildings against the roundish shapes of the hills. There's an intense triadic color scheme of reds, yellows, and blues. Most of the textures are carefully separated. You can see a corrugated roof stamping, a tile roof texture painted with a no. 8 round sable brush, a burlap stamping on the wall of the bell tower, a flat mat-board stamping on the lower right-hand roof, a corrugated edge stamping over the hanging drapery, a rubber-mat "squares" stamping next to the arch doorway, scrape-offs in the grass and tree bark, and bark textures that were painted with a pointed brush.

So far we have discussed the contemporary theories in depth, along with additional information throughout the step-by-step demonstrations, including color plans, color properties, and color moods. Experimental techniques also have been explained in detail, with practice exercises, examples, and applications included, and shown in step-by-step demonstrations and additional examples. Techniques in themselves can be considered "gimmicks," but when applied to paintings of real caliber, they act as realistic or symbolic supports to a master plan.

There's more to getting real substance into a painting than imitating a landscape or seascape as it appears. We have cameras for this purpose. A painting must be energetic enough to excite viewers and interesting enough to hold their attention. You also may leave some things undefined to invite their participation, and to play on their imagination.

You must be aware of many design principles as your painting develops:

Design theme • Tensions • Distortions • Moods • Interesting colors and textures • Repeated shapes • Overlapping planes • Designed positive and negative shapes • Light passages • Flattened depth of field • Push-pull manipulations • Abstract patterns • Soft and hard edges • Interesting glows and glazes • Variations in sizes, shapes, colors, tones, textures, and details.

Most of these design principles have been discussed earlier, but I'll review some of the basic ones. In addition, I'll discuss some practical pointers on matting and framing your work and on making a filing system to keep track of your paintings. Finally, I'll answer some questions frequently asked by students.

REVIEWING COLOR

Hue. This refers to the actual color of objects, such as red, yellow, blue, and green, apart from the color of the lighting on the objects. Reds, yellows, and oranges create warm sunny moods (top), while blues, greens, and purples create cool rainy, wintry moods (bottom).

Value. This refers to the degree of lightness or darkness of the colors. Light values (top) set up light, airy, high-key moods. Dark values (bottom) set up mysterious, heavy, dramatic moods. (Watercolors are lightened by diluting them with water.)

Intensity. This is also called *chroma* and refers to the purity of the color. Rich, pure colors set up brilliant, vibrant sensations. Neutral or grayed colors create restful, subtle, peaceful moods. (Colors are neutralized by adding other colors to them, such as grays or color complements.

Color Property. This is often known as "color temperature." Cool colors *recede* (background) and warm colors *advance* (foreground).

COLOR PLANS

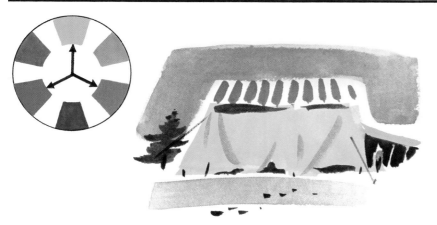

Triadic Color Plan. In a triadic plan, the major colors can be the three primary colors (red, yellow, and blue) or the secondary colors (violet, orange, and green), or you may select any other three colors equally spaced around the color wheel. The triadic reds, yellows, and blues will create the extreme in gay, circusy moods, while secondary colors will be less active.

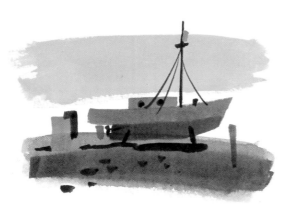

Complementary Color Plan. In a painting with a complementary color scheme, two colors from opposite sides on the color wheel are the predominant colors, such as red and green, blue and orange, or violet and yellow. These colors complement each other in pure form and neutralize each other when mixed together, setting up pleasing moods.

Analogous Color Plan. This plan uses three or four neighboring colors on the color wheel. These closely related colors set up warm moods if they're on the yellow-red-orange side or cool moods if they're on the blue-green-purple side.

REVIEWING ABSTRACT DESIGN

Horizontals and Verticals. To visualize a three-dimensional subject in two-dimensional space divisions and patterns, start with a selection of old newspaper photographs, such as ones of news events and sports. With a felt marking pen, first pick out all the horizontal lines in the photograph, drawing right over them. Next, indicate all the vertical lines. Quite often, they'll set up interesting unequal space divisions.

Diagonals. Now pick out all the angular (oblique) lines. Also look for a number of counter (opposing) angles. Mark over all these lines with the marking pen. These lines will set up the conflicts of forces and counterforces. They're particularly evident in sports photographs.

Curves. By this time, you'll note that we're dividing a three-dimensional photograph into flat, two-dimensional divisions and patterns of space. However, until now we've emphasized only straight-line divisions. So for contrast, search out all the curves in the photograph and mark them with a pen. As you learned in the "Modern Theories" chapter, when the emphasis in the composition is on only one of the four themes (vertical, horizontal, diagonal, or curved), it sets up a particular mood.

Example 1. This study and the next one were made on location during a workshop. In this diagram, notice the strong horizontal line that starts above the garage door and the strong vertical line behind the student painting on the patio. They divide the major spaces unequally. Additional shorter-length horizontal and vertical lines divide the composition into smaller units.

Now notice the oblique angles leaning to the right in the tree and in the student's legs. These are countered with opposing obliques in the drawing board that's leaning against the tree and by the student's easel. The fence also has oblique lines, top and bottom. Finally, numerous curves are selected to complement all the angles and rectangles. The three-dimensional subject has now been reduced to its exciting abstract elements. Do you sense the feeling of conflict, movement, and animation in this sketch?

Example 2. This diagram shows a view looking from an overpass toward a slope of homes and apartments. The abstract space divisions, diagonals, and curves have been sketched in with lines, and negative passages have been filled in with dark values. These are suggested in the patterns formed by windows, doorways, and openings between the columns of the overpass.

After reducing subjects to flatter, more abstract shapes and patterns, emphasis can be applied to exciting inventive color passages, experimental textures, and other surface qualities during the painting. Total creative processes can now take over. Exaggeration and distortion of these linear tensions and patterns may carry abstraction to an even higher degree. For example, Picasso and Braque went a step farther by "fracturing" shapes and forms and reconstructing them in distorted symbols of still lifes and figures.

A GUIDE TO EXPERIMENTAL TEXTURES

Here's a quick checklist of experimental techniques from which you can pick and choose, listed in the usual order of application. Use it as a guide to follow when you're painting.

1. Prepare the paper (before wetting) by folding, creasing, crushing, burnishing, scratching, or sanding. Mask out desired areas with masking tape, Frisket paper, Maskoid liquid, or rubber cement; or use resists such as paraffin or crayon.

2. Wet the paper with a moist sponge or by submerging it in water.

3. Apply washes, reserving the whites and light passages.

4. Drop salt, alcohol, or water into wet or moist pigment areas.

5. Lift off or scrape out color while the pigment is still wet or moist, using paper towels, tissues, blotters, sponges, brushes, cards, cut mat boards, tapered brush handles, and so forth.

6. Splatter paint on with a brush, toothbrush, or toothbrush and template.

7. Stamp the paper with mat board, sponges, corrugated paper, burlap, packing papers, and other textured materials.

8. Add edge stampings with the edge of a mat board, with thinner boards for bends and curves, or with the cross section of corrugated boards.

9. Mask out shapes with tag-board templates and lift out areas with a moist sponge.

10. Block out other areas with a tag-board template, and splatter pigment on uncovered sections with a toothbrush.

11. Perform lift-offs and scrape-outs with razor, knife, sandpaper, or sponges and templates.

12. Apply glazes of diluted pigment to alter colors and tones or to pull textures together.

13. Add calligraphy or linear strokes last on dry paper with a pointed brush, pen and ink, felt pens, or through final edge stampings or razor-blade scratches for the finishing touches.

Remember: Reserve quiet areas!

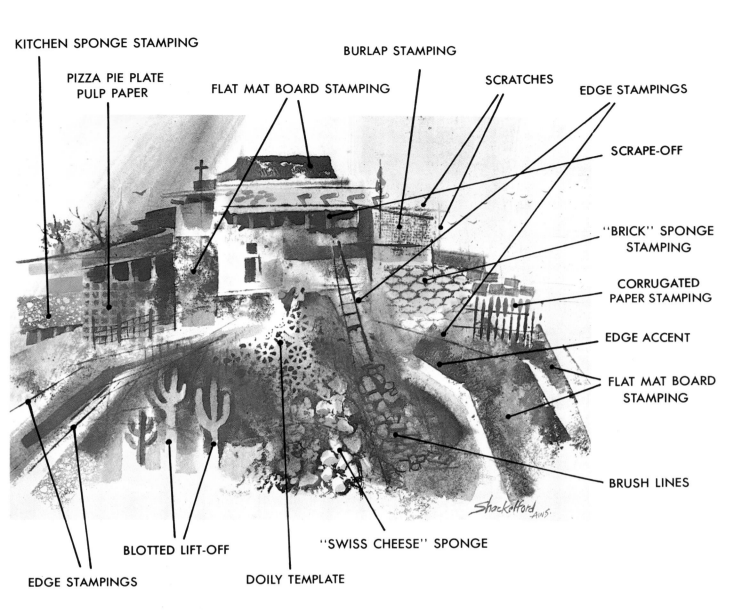

KITCHEN SPONGE STAMPING

PIZZA PIE PLATE
PULP PAPER

FLAT MAT BOARD STAMPING

BURLAP STAMPING

SCRATCHES

EDGE STAMPINGS

SCRAPE-OFF

"BRICK" SPONGE
STAMPING

CORRUGATED
PAPER STAMPING

EDGE ACCENT

FLAT MAT BOARD
STAMPING

BRUSH LINES

"SWISS CHEESE" SPONGE

BLOTTED LIFT-OFF

DOILY TEMPLATE

EDGE STAMPINGS

Indian Pueblo, *by Bud Shackelford.* This painting is loaded with a variety of textures, yet through careful handling and because of many light passages and rest areas, they're compatibly blended. Although the painting has many neutral colors, the most intense colors are reds, yellows, and blues, setting up a triadic color scheme. Strong lead-ins from the base of the cliff direct the eye to the center of interest, the church with the two figures. The doily pattern below the figures is created by spraying toothbrush splatter (thumb method) over a doily used as a template.

Following Page
Mission Tranquility, *by Bud Shackelford.* This painting has numerous textures and much surface excitement. Notice how the intense flat colors (pure reds, oranges, and magentas) set up juicy focal points. A complementary color scheme was used, with greens and reds predominating. The painting also illustrates several different methods for creating the texture of trees and rocks. It also contains a tremendous variety of shapes, sizes, and colors. Notice the color changes in several of the edge stampings.

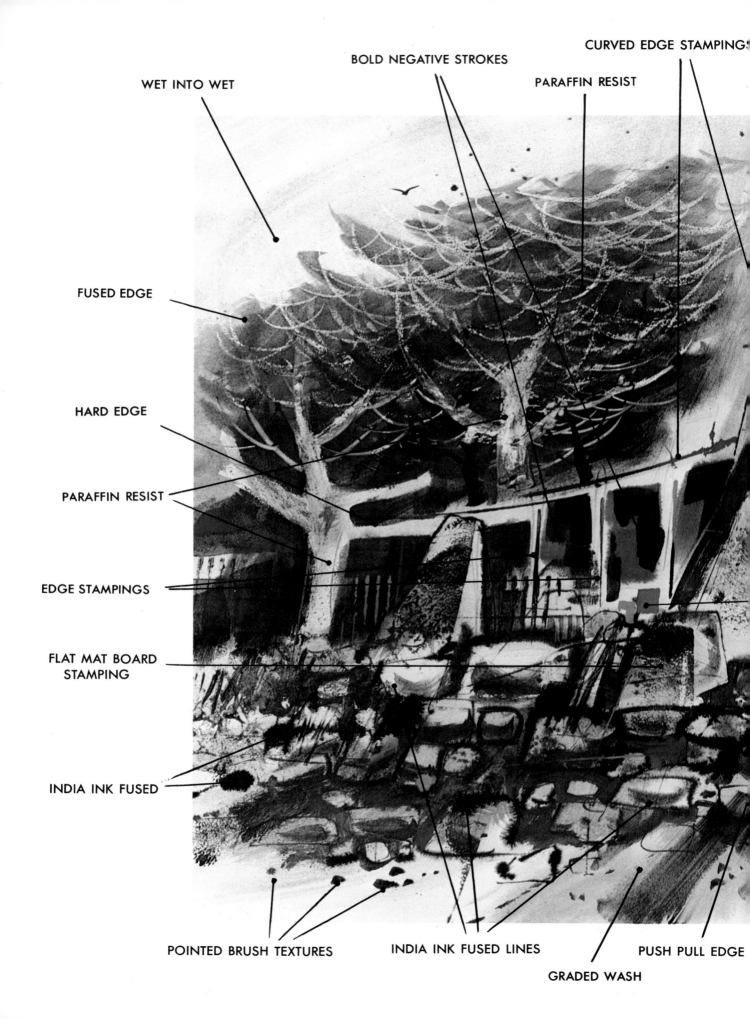

WET INTO WET

BOLD NEGATIVE STROKES

PARAFFIN RESIST

CURVED EDGE STAMPING

FUSED EDGE

HARD EDGE

PARAFFIN RESIST

EDGE STAMPINGS

FLAT MAT BOARD
STAMPING

INDIA INK FUSED

POINTED BRUSH TEXTURES

INDIA INK FUSED LINES

PUSH PULL EDGE

GRADED WASH

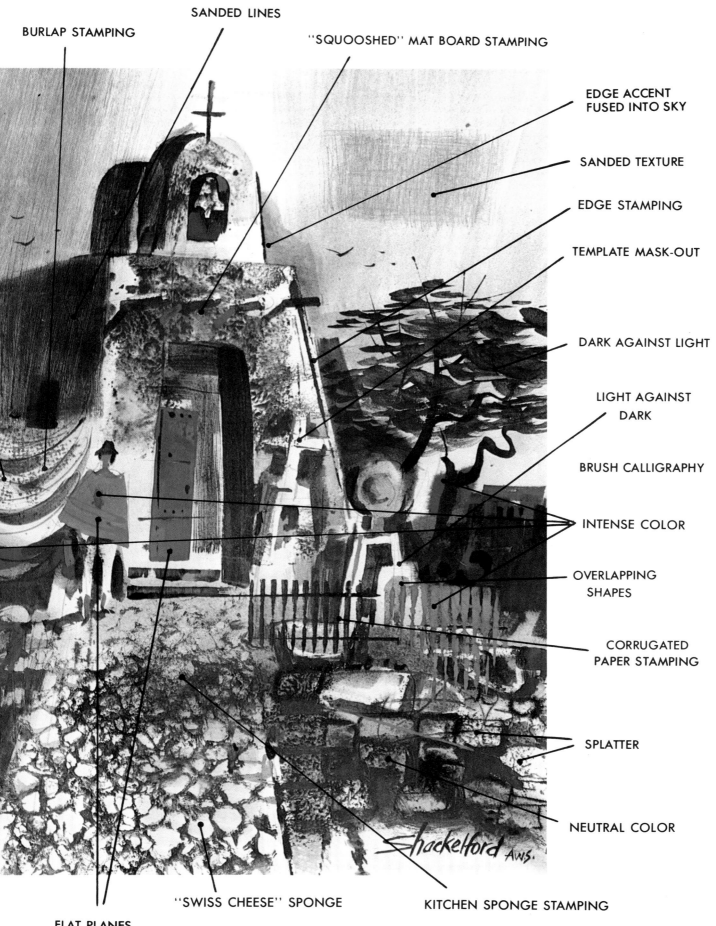

BURLAP STAMPING

SANDED LINES

"SQUOOSHED" MAT BOARD STAMPING

EDGE ACCENT
FUSED INTO SKY

SANDED TEXTURE

EDGE STAMPING

TEMPLATE MASK-OUT

DARK AGAINST LIGHT

LIGHT AGAINST
DARK

BRUSH CALLIGRAPHY

INTENSE COLOR

OVERLAPPING
SHAPES

CORRUGATED
PAPER STAMPING

SPLATTER

NEUTRAL COLOR

SPLATTER

KITCHEN SPONGE STAMPING

"SWISS CHEESE" SPONGE

FLAT PLANES

Shackelford AWS.

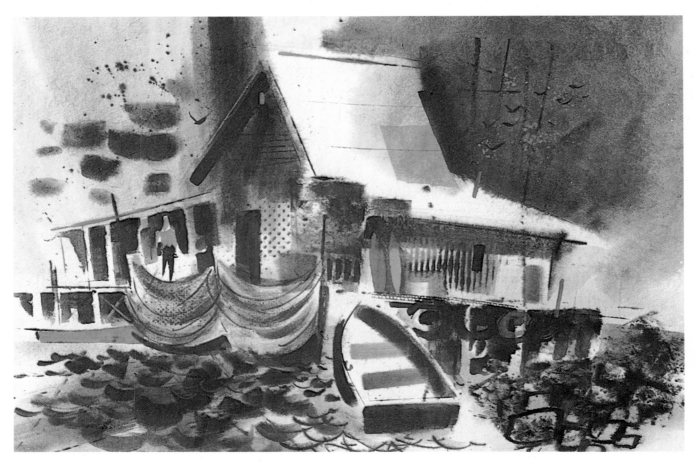

Boat Shack, *by Bud Shackelford*. This is a good example of rest areas placed next to active textured areas. The sky, roof, and space passages between textures are rest areas. The flat orange pattern on the roof is also a quiet shape. Textures include brush splattering and toothbrush splatter for the sky, short blended brushstrokes for the clouds, pen and India ink on moist paper for the rocks, and others shown in the detail below. An analogous color scheme in warm colors was selected. The alternating stamped textured areas and rest areas are described from right to left as follows: The busy corrugated stamping is complemented by two flat painted surfboards, then a white space, and then a flat mat-board stamping (black and burnt sienna, with two variations below), then a light area with a packing-paper dot stamping, continuing to a flat dark negative door and dark negative shed opening. An intense cobalt violet sets up a figure as a focal point, playing light against dark. The reverse occurs where dark legs appear against a white background. This white area becomes an important breathing space between the building and the nets. The burlap texture in the nets is separated from the water by a blackish tone. The rowboat itself and the surrounding area are bathed in whites, and the seats have become exciting, flat, color patterns.

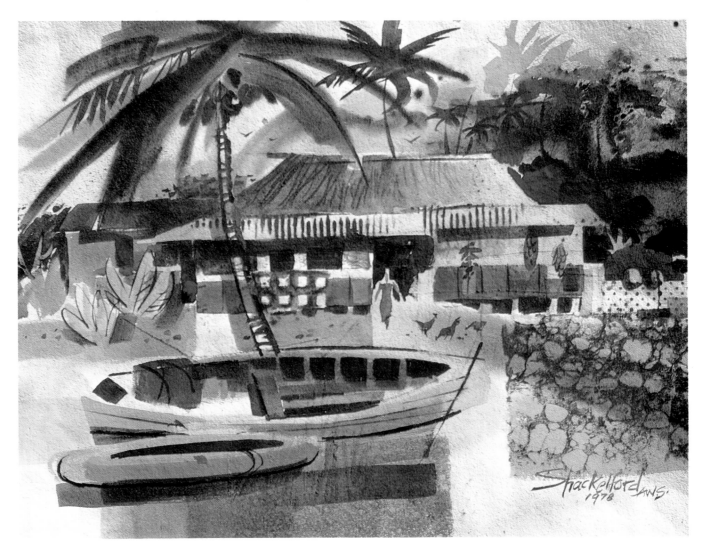

Tahitian Shop, *by Bud Shackelford.* This painting combines three dimensions with two dimensions. The flattened areas are the dot-patterned fence, the foreground rectangle of rocks, the plants and ground patterns below the buildings, and the distant yellow-green palm leaves. Notice the color variations in the trees and foliage, and the nice control of soft and crisp edges throughout. Only one branch shows the palm-leaf texture on the foreground tree (done with a no. 8 round sable brush). You can see the knife

scratches that create the thatched roof texture, corrugated-board stampings that set up the tin-roof overhang, a dotted packing-paper fence stamping (on the right), a sponge rock stamping in the right foreground (kept flat with a glaze of phthalo blue over it), and calligraphy with a round sable brush that creates the texture of the palm tree trunk. Notice the many rest areas and open passages between major shapes and textures.

Following Page

Sails Race, *by Bud Shackelford.* Creating the effect of an animated regatta, this painting displays spinnakers (large, balloonlike sails) in full wind, sails in conflicting obliques, sweeping curves against angles, and numerous texture applications. The buoy becomes a focal point because of its rich, intense, flat oranges and reds, with the negative patterns of its superstructure painted blue. Dark tonal accents can be found around the sails, the buoy, and the sun. The painting also contains a lot of light passages and rest areas that complement the numerous textures. The great masses of neutral colors act as a foil for the many small intense colors, creating interest all over the surface of the painting.

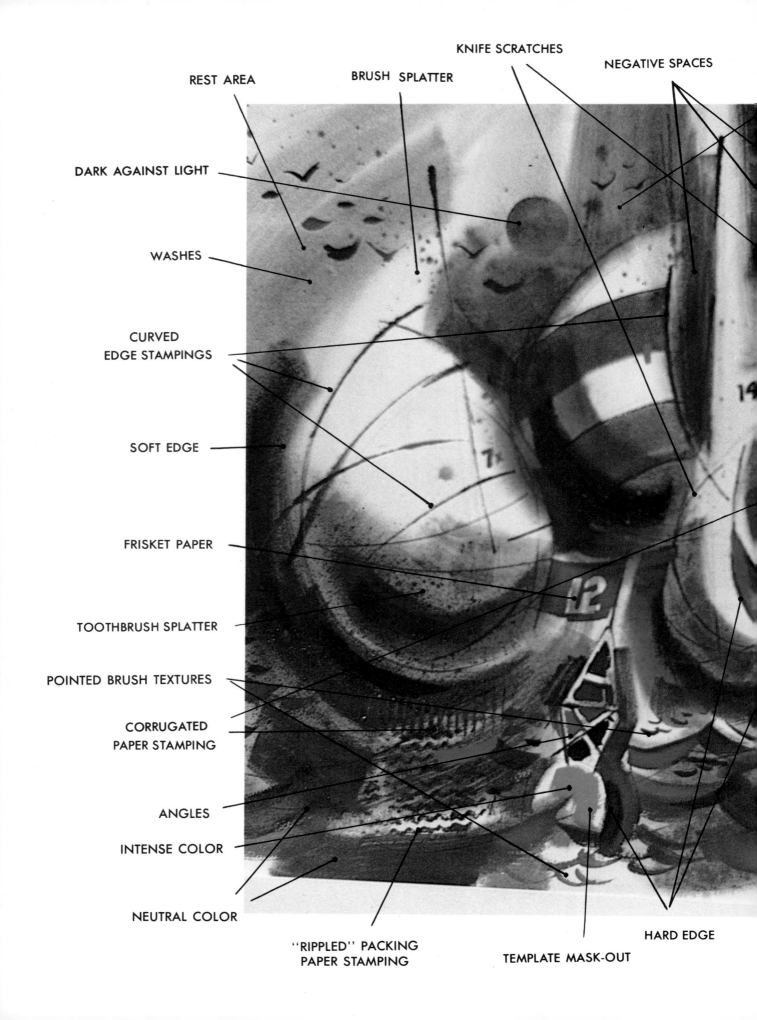

REST AREA

BRUSH SPLATTER

KNIFE SCRATCHES

NEGATIVE SPACES

DARK AGAINST LIGHT

WASHES

CURVED
EDGE STAMPINGS

SOFT EDGE

FRISKET PAPER

TOOTHBRUSH SPLATTER

POINTED BRUSH TEXTURES

CORRUGATED
PAPER STAMPING

ANGLES

INTENSE COLOR

NEUTRAL COLOR

"RIPPLED" PACKING
PAPER STAMPING

TEMPLATE MASK-OUT

HARD EDGE

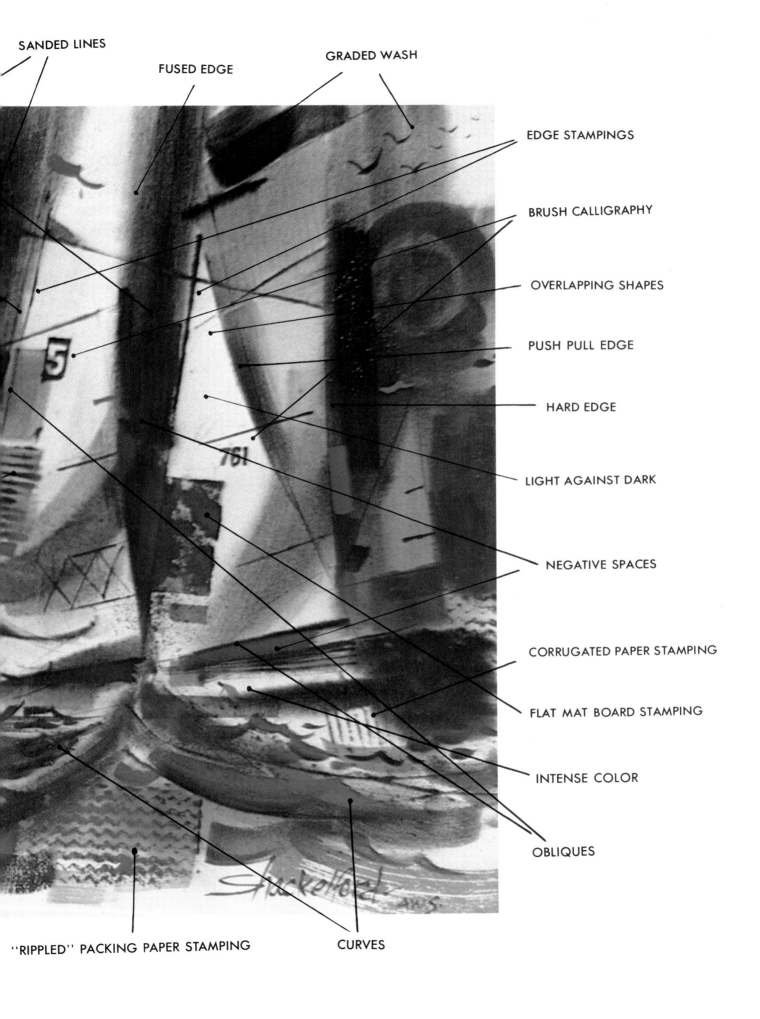

SANDED LINES

FUSED EDGE

GRADED WASH

EDGE STAMPINGS

BRUSH CALLIGRAPHY

OVERLAPPING SHAPES

PUSH PULL EDGE

HARD EDGE

LIGHT AGAINST DARK

NEGATIVE SPACES

CORRUGATED PAPER STAMPING

FLAT MAT BOARD STAMPING

INTENSE COLOR

OBLIQUES

"RIPPLED" PACKING PAPER STAMPING

CURVES

TIPS ON FRAMING AND EXHIBITING

1. A "trial" mat is useful to view your near-finished painting before applying the final touches. Make them in three sizes, for full-sheet, half-sheet, and quarter-sheet watercolors. Cut the openings ½" (13 mm) smaller than the watercolor sheet and maintain a 3" (7.5 cm) width all around, except for the base, which can be 3¼" (8.5 cm). An extra piece of mat board can serve as a backing. Hinge it at the top with white tape, 1" (25 mm) wide. To evaluate your nearly finished painting, simply position it in the mat and secure it on both sides with short strips of masking tape. You are now viewing it as a matted painting, separating it from the brownish board. The mat is an important element in the overall design of your painting.

2. When mounting your painting in a permanent mat, use white self-adhesive tapes. Masking tapes and gummed tapes with brownish dyes may eventually discolor the artwork because they are absorbed into the paper.

3. Some painters protect matted paintings with a sheet of clear acetate. This can be taped under the window of the mat, overlapping behind the window about 1" (25 mm) all around and secured with white tape. Another method is to cover the entire matted painting with acetate, folding it around the mat and taping it to the backboard.

4. A top layer of glass or ⅛" (3 mm) clear Plexiglas is very important to restore luster or life to a watercolor. It also protects the painting from the atmosphere. But clear glass is preferable. Nonglare glass reduces the glaze impact of the watercolor painting and is therefore less desirable. You can eliminate glare instead by lighting your painting properly.

5. Although framing is a matter of personal choice, it still requires common sense. You wouldn't want to frame a light, delicate work with heavy elaborate molding or a dark color. You'd also put a contemporary painting in a contemporary frame, such as an aluminum, or Plexiglas, strip-molding frame, rather than an old-fashioned, hand-carved frame. In some cases, a painting can even be floated on a wider sheet or mounted flush to the extremes of the frame, without a mat. Some strongly designed watercolors look great framed in massive wooden frames (possibly hand-carved), with linen liners built into the frame. If you don't use linen liners, mats approximately 3" (7.5 cm) wide should be used instead, to separate the watercolor from the frame.

6. I prefer to use frames of neutral colors that pick up some of the hues in the painting, such as the tones of driftwood or darker stains like walnut or mahogany, if the colors in the painting are strong enough to hold their own.

7. Use strong eye-hooks and good, thick picture wire to avoid any possibility of the hooks pulling out or a string or thin wire breaking. Many

a fine glass-covered watercolor has been destroyed after slipping from the wall.

8. There are many possibilities to exhibit your work these days, both locally and nationally. One way is to enter open shows sponsored by art clubs and watercolor societies, which are usually competitive. Joining these organizations may also give you additional advantages, though you don't necessarily have to be a member to exhibit with them. Current and future shows are listed in many art club bulletins, and national art shows are listed in art magazines available through subscription or at your local art supply stores.

As you become more professional, you'll find that there are private and commercial art galleries in every major city looking for new talent. Usually your work is shown on consignment, with the gallery taking a percentage of the sale price on sold works. For a listing of them, look in your local telephone "Yellow Pages" under "Art Galleries."

9. Spend time selecting good titles for your paintings because they can be very important in setting a mood. Since it is difficult to remember all your sold works by title, as a professional person, you must set up a business procedure for recording your work.

I use 4″ × 6″ (5 × 7.5 cm) file cards, kept in steel file cabinets 16″ (40 cm) deep (available in office-supply stores). I clip a Polaroid photograph of the painting to the lower left-hand side of the card and record on the card its complete history: title, date, dimensions, medium, where it's been exhibited and at what price, any awards it has received, and so forth.

10. I also keep a "gallery file," and when a painting is currently being exhibited at a gallery, I place the card in this file and list the gallery price and other particulars on it. When it's returned, I record the date and place the card back in my active file.

When a painting is sold, I record the name and address of the new owner (if the gallery releases it to me) and the price paid for it, and transfer it to a "sold paintings file." You should also keep a sales record of your paintings for tax purposes and for your own information.

11. Keep all receipts on art materials and matting and framing materials; they're deductible against your painting sales for income-tax purposes. I keep a complete business record monthly, including major equipment purchases, which can be depreciated.

12. Pricing your work might take some research. You may get advice from galleries, but by carefully comparing your work with similar works in shows and galleries, you should be able to set a fair price on it. But don't underprice your work too severely or the customer's evaluation may also be undermined. On the other hand, if you overprice it, you may have trouble selling it.

QUESTIONS AND ANSWERS

How can I elevate the quality of my own work?

Much can be learned from others through observation. I gain so much inspiration from top-caliber art museum shows that I can hardly wait to get back to the drawing board. Discover your library, and absorb the great art treasures in books available to you. Also, investigate painting workshops and classes available locally or nationally advertised in art magazines such as *American Artist* and *Art News*. You also may get painting tips and inspiration from these magazines.

Should I study oil painting first?

I see no need to study oil first (which some consider an easier medium). It's more important to learn to draw well and understand the fundamentals of drawing and painting before selecting your favorite medium. Watercolor is more direct than oil, and you must reserve the white of the paper instead of using white pigment. The proper approach is to paint light to dark, and it's not too difficult once you learn this secret.

Watercolors are now often taking the top awards in all-media shows. Watercolor is as important a medium as oil and, because of its spontaneity and great color translucency, is a most exciting medium.

Is watercolor as permanent as oil?

Yes, and in many cases, watercolor painted on good rag paper may even outlast oils, which may crack and darken with age if improper techniques have been used. Otherwise, both mediums are considered permanent.

How can I prevent my colors from getting muddy?

Primarily by getting the color and value right in the first application and by avoiding going over them too often. Yellow ochres and other earth colors have more sediment in them and tend to muddy other colors; you might try to avoid them, especially in mixtures. Also, wait until your colors are dry before glazing over them with other diluted colors.

Do you prefer tube colors to pans or cakes?

Yes. For studio painting, I prefer a large palette with tube colors kept in fresh condition. (See the "Materials" chapter, where I discuss my homemade palette.) I use lots of fresh pigment for rich, spontaneous painting. It takes too long to soften cake or pan colors with a brush. The new Strathmore LeFranc & Bourgeois tube watercolors are excellent and offer a lot more for the money. For outdoor study, reference, or color sketches in natural-history museums, zoos, and so forth, I use the Winsor & Newton pan colors in a special palette shown earlier. It folds to pocket size and won't run. It also produces a surprising amount of color easily, and doesn't stain the mixing surface of the palette.

Should I use Chinese white?

Any water-based color, including acrylics and opaques, will qualify as a watercolor for most major shows if it's on paper and framed behind glass. Most watercolorists are still "purists," however, and prefer to use Chinese white only for corrections—and even then disguise it as much as possible so it isn't recognizable. A touch of yellow ochre added to the white will remove the chalky look.

Can I use spray coatings over watercolors?

No. You should avoid gloss sprays, gloss fixatives, varnishes, or any obvious coatings over watercolors, since a glass covering makes it totally unnecessary. If you wish to omit the glass, you may use workable fixative, which can seal the surface to some extent. Workable fixative may also be used to deepen the tonal strength of a passage in the painting that has dried to a lighter value. I have also used it to strengthen portions of my watercolors, and you can also paint over workable fixative without the color crawling or beading.

Why use unorthodox methods for creating textures?

In this era of inventiveness, the surprise element has value. When we divide flatter paintings into space divisions, the surface qualities are emphasized; and with experimental colors and textures, all parts of the painting can become exciting. The brush alone has limitations. In this book you'll find many additional texturing methods to supplement your brush techniques.

Do you prefer studio painting to working outdoors?

Yes. I now paint my most serious works in the studio, since I use many materials and tools for acquiring exciting happenings and textures. My concentration is more focused in the studio because there are fewer distractions (such as weather and observers) and more all-around comfort there. I also have good music available, which helps set an inspiring mood; and everything else I need is on hand too.

However, I do work from reference material gathered in the field, and most of my on-location work is now in the form of studies from nature. (My field equipment is described in the "Materials" chapter.) Though I use 35-mm Leica cameras and occasionally Polaroids for detail reference, I prefer to use my own sketches with notations, since these are more apt to capture the essence (the first-glance excitement) of the subject. Felt pens and color glaze equipment are now my favorite on-location tools, along with 11" × 14" (27.5 × 35 cm) drawing pads or quarter-sheet Aquarius II papers.

CONCLUSION

We're living in a century of experimentation and inventiveness in the visual arts, an outgrowth of the exciting Impressionist and post-Impressionist periods. This book is intended to stimulate your creative processes and guide you toward painting with real substance.

We've discussed major modern theories designed to encourage more creative painting and have stressed strong design principles, flattening space, creating exciting color and texture passages, applying tensions and distortions, setting up themes and moods, designing negative passages—painting, as always, with gusto and spontaneity.

Remember to keep an open mind and always search for fresh viewpoints. Avoid falling into ruts. For stimulation, see your library art section and visit galleries and art museums, keeping a watchful eye out for traveling shows, and subscribe to current art magazines. Finally, analyze your own work and cultivate your strong points. Each and every painting should be a new adventure.

BIBLIOGRAPHY

Betts, Edward. *Master Class in Watercolor.* New York: Watson-Guptill Publications, 1975.

Brandt, Rex. *The Winning Ways of Watercolor.* New York: Reinhold Publishing Co., 1973.

Brommer, Gerald F. *Transparent Watercolor: Ideas and Techniques.* Worcester, Mass.: Davis Publications, 1973.

Brooks, Leonard. *Painting and Understanding Abstract Art.* New York: Reinhold Publishing Co., 1964.

Curry, Larry. *John Marin, 1870–1953.* Los Angeles County Museum of Art, 1970.

Hess, Thomas B. *Willem de Kooning.* New York: The Museum of Modern Art, 1968.

Hill, Tom. *Color for the Watercolor Painter.* New York: Watson-Guptill Publications, 1975.

Loran, Erle. *Cézanne's Composition: Analysis of His Form with Diagrams and Photographs of His Motifs.* 3rd ed. Berkeley and Los Angeles: University of California Press, 1963.

O'Brien, James F. *Design by Accident.* New York: Dover Publications, 1968.

Wood, Robert E., and Nelson, Mary Carroll. *Watercolor Workshop.* New York: Watson-Guptill Publications, 1974.

INDEX

Edited by Bonnie Silverstein
Designed by Jay Anning
Graphic production by Hector Campbell
Set in 11-point Trade Gothic light